IMAGES
of England

AROUND
FROME

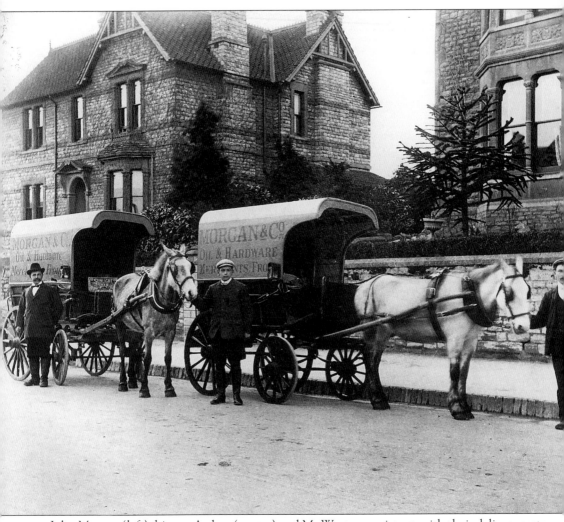

John Morgan (left), his son Arthur (centre) and Mr West, an assistant, with their delivery carts in Christchurch Street West around 1910. The family ran a variety stores at No.14, Christchurch Street East. They described themselves as oil and hardware merchants. Were they always so smartly turned out or was this for the benefit of the camera? The imposing villas behind the convoy are built of white lias from Radstock, an unusual material in Frome. The picture was taken by W.F. Wheeler, Frome's ' art photographer'.

IMAGES
of England

AROUND
FROME

Compiled by
Micheal McGarvie

TEMPUS

Acknowledgements

I have been collecting photographs of Frome and district for thirty years. Some I have bought, others have been given by kind friends, many more have been lent for copying. With so many people over so many years, it is impossible to thank everyone individually and I hope a general and heartfelt expression of my gratitude for so much support and interest will be acceptable. Likewise many of the photographers are unknown and one can only hope that they would have been pleased to see their work once more in print.

I would like to thank in particular the Marquess of Bath, the Earl of Oxford and Asquith, Messrs G.H. and R. Boyle and the family of the late Arthur Duckworth, of Orchardleigh, for allowing me to draw on their family collections. Gerald Quartley and Mr and Mrs L.V. Bowring have provided photographs over many years. I have used samples from the collections of J. Thomas, the late Peter Fry, the late Mrs. M. Ashman and the late Mr and Mrs N.F. Maggs. Mrs W.E.I. Eliot, Peter and Marcia Newbolt, Miss B. Starr and Mr James White also gave and lent me photographs. Others came from the collection of the late Miss R.M. Polehampton via Miss Mary Good. I should also like to thank Mr M.J. Tozer, Mrs Wood, Fred Chant, George Bradbury and Mr Roddy Wheeler. Some prints came from the collections of the Society of Antiquaries of London and the Somerset Archaeological and Natural History Society. I remember gratefully the work of the late George H. Hall.

First published 1997, reprinted 2002

Tempus Publishing Limited
The Mill, Brimscombe Port,
Stroud, Gloucestershire, GL5 2QG

British Library Cataloguing in Publication Data.
A catalogue record for this book is available from the British Library.

ISBN 0 7524 1041 5

Typesetting and origination by Tempus Publishing Limited
Printed in Great Britain by Midway Colour Print, Wiltshire

Contents

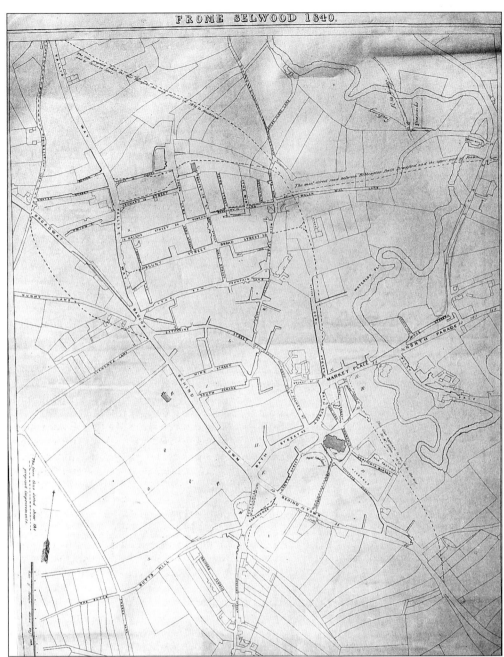

Traffic problems in Frome seem to be perennial. Congestion by vehicles in the eighteenth century led to the creation of North Parade and Bath Street but the difficulties have persisted down to our own day. This map of 'proposed improvements' was drawn up in 1840 in an attempt to distribute traffic more evenly. The solutions were radical but never carried out. The map, reproduced courtesy of the Somerset Record Office, gives a good impression of the industrial town in its rural setting. Photograph by George H. Hall.

Introduction

Frome is an unpretentious, working town, 15 miles south of Bath, proud to be in Somerset but so close to the border that it is often referred to as 'near Wiltshire' or even as in that county. It is so out on a limb from the Mendip district of which it now forms part, that it might have been better administratively if it had been in Wiltshire. The town has a reputation for a relaxed attitude to life of almost Irish proportions, the Frome apathy of legend, accounted by some as the reason for the longevity of its inhabitants, although others ascibe this virtue to its many hills.

It must be admitted that Frome has never troubled much to make known its pleasant attributes (although the founding of the Tourist Information Centre may change this) indeed, it has been said that Frome celebrates many occasions which in other places pass without remark. After little change for 150 years, Frome has doubled its population in the last thirty years to around 25,000 people. This has made its mark in traffic congestion and on limited facilities, but has not affected the essential spirit of the town.

In common with other places, vandalism, anarchy and dirt, may have marred Frome's image in recent years but broadly it remains a caring community, kindly and friendly, gregarious and generous, held in (sometimes exasperated) affection by its residents. It has good communications, a pleasant setting, and is rich in historic buildings and architectural detail.

The word Frome is derived from Welsh *ffraw*, basically meaning running water, referring to the river on which it stands. It is pronounced to rhyme with 'room', as if spelled with a double 'o' (as it was on occasion) but probably reflecting the long vowel of our Saxon forebears. To distinguish it from other places of the same name, the town was once called Frome Selwood, a reference to the royal forest, the sallow wood, which lay to the south west.

The Little Guide to Somerset declared in 1907 that 'with the exception of a little faint-hearted sympathy for Monmouth, Frome has never helped to make history'. Perhaps not, nevertheless, its local history is rich enough. Twelve years ago, Frome celebrated its 1,300th anniverasry. It was sometime around the year 685 that St Aldhelm, Abbot of Malmesbury and kinsman of King Ine of Wessex, founded a monastery here which he dedicated to St John the Baptist, the saint who preached in the wilderness.

The site was a rocky, north facing hillside by a spring in the forest. That it was never meant to be a town accounts for Frome's unusual topographical position on hills rising from a steep-sided valley. This has caused problems ever since. Aldhelm endowed his church with a great tract of land which later became West Woodlands. Due to the prestige of the royal founder the Kings of Wessex came to Frome and hunted in the forest. Athelstan held a 'Witan', or Great Council, at Frome in 934 and King Edred died here in 955.

At the time of the Domesday Book in 1086, the manor was ancient demense of the Crown and there was a flourishing market. The Saturday market is still held today. Early in the twelfth century, Henry I gave Frome to Roger de Courseulles, and the church lands to Cirencester Abbey. This set the pattern in Frome for the entire Middle Ages. From 1235, the Lords of Frome lived out at Vallis, an uneasy relationship existing between manor and church.

Before 1300, the invention of the fulling mill changed the history of Frome. The woollen industry had been based in the towns, it now needed water power and moved to the country. Frome and its hinterland became a hive of the industry for centuries, declining from the eighteenth century but not disappearing until 1965. Amid the thump of the hammers, the humdrum life of Frome went on punctuated by occasional excitements and terrors.

In 1270, a fair, the ancestor of the present carnival, was granted. Edward I came here in 1276. In 1348, the Black Death struck. The lord and most of his tenants died. About 1470, the almhouse, now the Blue House, was founded and in 1494 Henry VII established a second

market day on a Wednesday. John Leland, the king's antiquary, came to Frome in 1540 and found it standing in the cleft of a stony hill with a 'metly good market', 'fayre stone howses' and a bridge of five arches.

With the Reformation, in 1542, the Thynne family, later Marquesses of Bath, came onto the local scene which they have not yet left. The wool industry had its ups and downs but was still the staple trade of the town. Monmouth came in 1685 during his ill-fated rebellion against James II. He stayed in Cork Street and men called him king as if he already had the crown on his head.

From the late seventeenth century the wool trade flourished and Daniel Defoe in 1725, found that Frome had grown 'prodigiously'. He thought it likely to become 'one of the greatest and wealthiest inland towns in England'. This did not happen, but the influx of tradesmen led to the building of Trinity, said to be the earliest area of industrial housing in the country. Much was demolished in the 1960s but what remained has been well restored by Mendip District Council.

Frome was described 'a grand hive of schism' and many chapels still reflect the size and prosperity of the nonconformist community. Rook Lane, built in 1707, is regarded as one of the finest chapels in the west of England. A leading member of the Congregationalists was Elizabeth Rowe, once a poet of international repute. In 1720, the Blue House was rebuilt to include a school to vie with the Edward VI Grammar School. The great Sanskrit scholar, Sir Charles Wilkins, was born in Frome in 1749.

Strangely, Frome was never incorporated as a borough. As far as it was governed, it was by the vestry and the courts of the Marquess of Bath and the Earl of Cork and Orrery, who bought the manor in 1751. A constable tried to control petty crime and the many riots had to be suppressed by the Militia.

The decline of wool brought a period of great economic distress to Frome in the first half of the nineteenth century. There was much immigration to Canada and Australia. Matters improved with the introduction of the new industries such as printing, brass and iron founding and the brewing of Frome's strong beer. The town became a Parliamentary borough in 1832 (to 1885) and the railway arrived in 1850, stimulating trade and travel. Sir Benjamin Baker, designer of the Forth Bridge, was born here in 1840.

In 1865 town government came at last with the Local Board which provided a hospital, a water supply and the Victoria Park. An Urban District Council took over in 1894 which survived until Frome was merged with Mendip eighty years later, a loss of independence viewed not without misgiving and regret.

Through all these vicissitudes Frome has endured. It does not wear its heart on its sleeve and not everyone likes or has liked it. The essayist John Foster thought it 'large and surpassingly ugly' and developed an intense loathing for it. Such a view is not unknown today. Mrs Katherine Ashworth summed up its dual character in a perceptive article in *Country Life* in 1955. She wrote that 'it clings to the sides of its two hills, and the motorist sweeping down the main Bath Road to the market place at the bottom finds little to hold his interest and is up and over the other side with no more than a passing glance. He sees only the modern façade which hides steep and narrow streets, many of them cobbled, lined with old houses, low windows, gables and carved wooden balconies. Here solid merchants' houses, two-roomed cottages, ancient smokey taverns and a chapel or two with a factory jammed between, all jostle for position, each from necessity holding up its neighbour'.

Nowadays, of course, the motorist would take the bypass and see nothing at all.

Micheal McGarvie
May 1997

One
From Past to Present

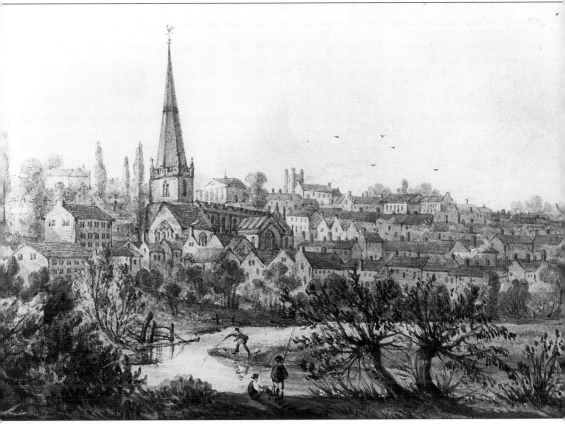

This view of Frome from Willow Vale was painted by W.W. Wheatley with some artistic licence in 1845. It captures well the congested nature of the old town with church and chapel, school and factory, together with myriad houses, huddled together on their steep, north-facing hillside. On the skyline from the left are the National School, the spire of St John's church, Rook Lane chapel and the tower of Christ church. Reproduced by kind permission of the Somerset Archaeological and Natural History Society.

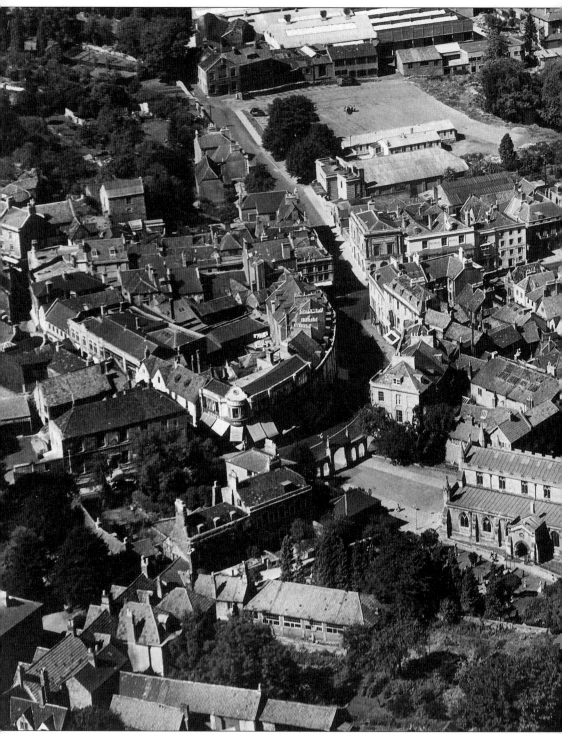

An aerial view of the heart of Frome, showing the great curve of Bath Street sweeping down past St John's church to the Market Place in 1954. Singer's factory (top left) and the Market Hall (top right) are prominent. The view well illustrates the rural character of the town forty

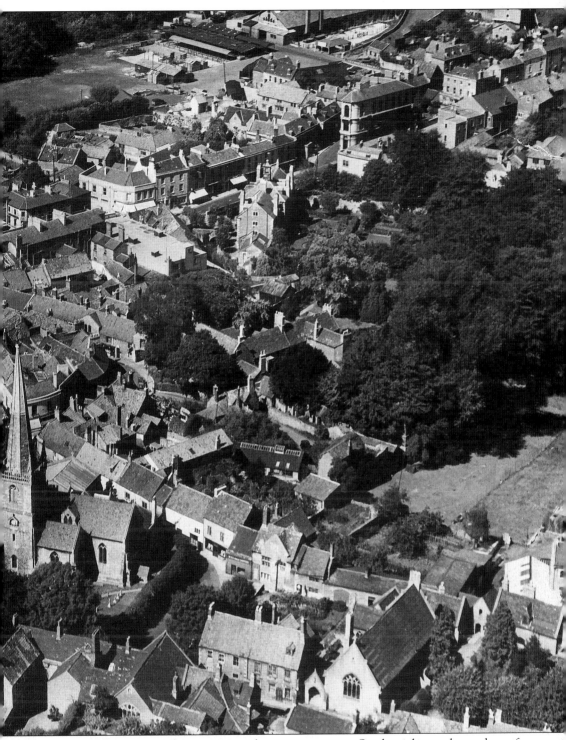

years ago with the countryside penetrating almost to its centre. On the right are the gardens of the Iron Gates, now lost to Safeway. Photograph by Aero Pictorial Ltd.

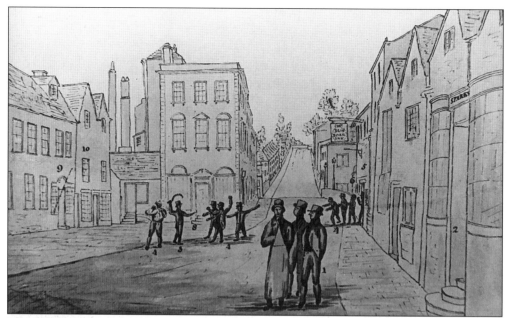

The Market Place, before the great Victorian redevelopment in 1820. Although North Parade (centre) had been cut in 1797, the Market Place still retained its seventeenth-century gabled houses and bow windowed shops. The square house in the centre, built before 1719 by William Wilkins, a salter, survived until 1936. The picture was drawn to illustrate a manslaughter case, when a fight was started, caused by tipsy farmers, resulting in a death.

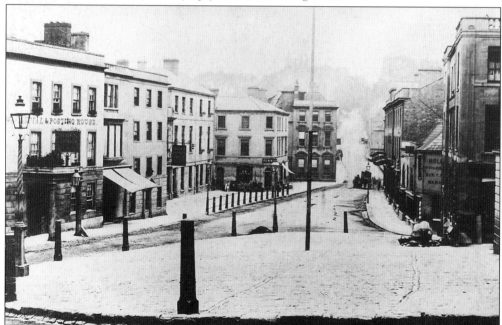

By 1865, the Market Place had been transformed and given a more imposing character. The area of setts in the foreground was where the produce market was held. The setts were removed in the 1890s. The George Hotel (extreme left) was remodelled in 1874. The porch was demolished by a runaway lorry in 1918.

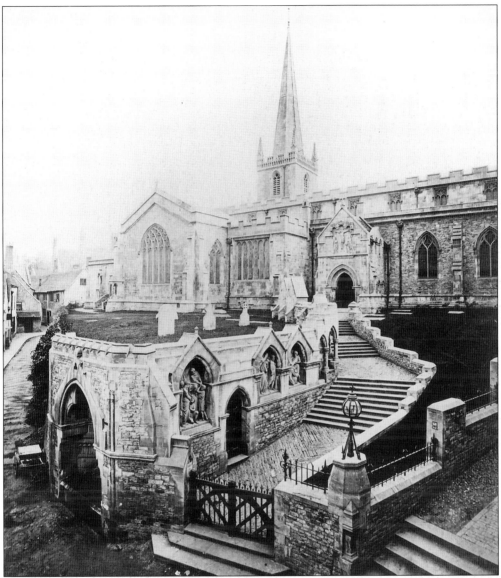

An atmospheric photograph of St John the Baptist's church soon after its extensive restoration and virtual rebuilding between 1860 and 1866. The work was undertaken by the Frome born architect, C.E. Giles for the Tractarian vicar, Revd W.J.E. Bennett. The *Via Crucis*, carved by J. Forsyth, is a rare and astonishing feature in an Anglican churchyard.

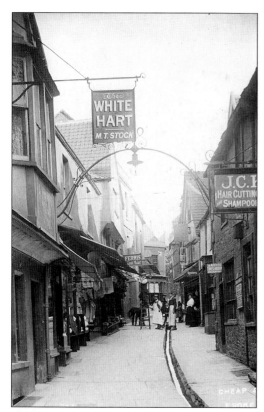

Cheap Street, *c.* 1910. The name, first found in 1500, and according to a Victorian guide book *The Bond Street of the Place*, means a market or place of trade. At this time it contained two pubs, the White Hart, shown here, and the Albion, now The Settle Restaurant.

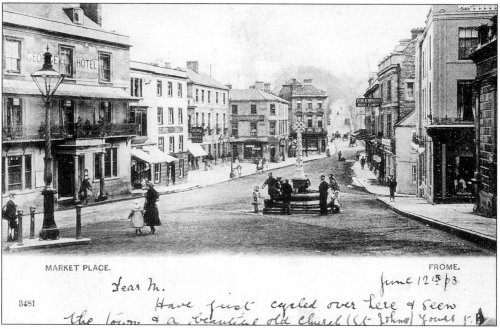

A leisurely scene in Frome Market Place, when the town was in one of its more relaxed moods, 1903. The fountain (used for washing fish on market days) and cross were given to Frome in 1871 by the Rector of Marston Bigot, Revd and Hon. R.C. Boyle.

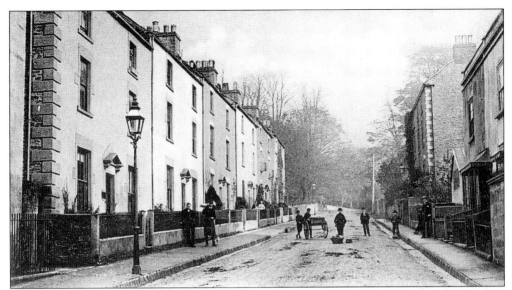

North Parade featured on a postcard around 1910. It replaced Bridge Street, the steep and winding medieval road, northwards out of the town, in 1797. It allowed direct access to the Market Place. The name was borrowed from Bath.

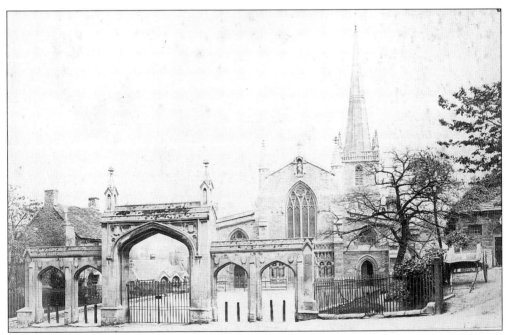

St John's church, 1870. Before 1814, the west front of St John's was hemmed in by houses including a pub. In that year it was cleared and beautified with the Gothic screen shown here. It was designed by the royal architect, Sir Jeffry Wyatville and erected by a local builder, Joseph Chapman, for £136.

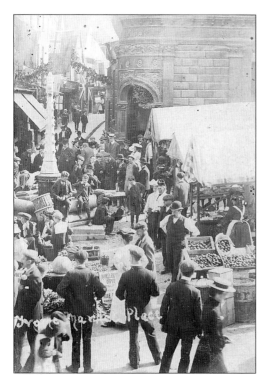

Frome market has a very old history, and was flourishing in 1086 when the crown received profits of 46s 8d from it. This more than usual animated scene may have been captured on film in August 1902, when Frome was celebrating the coronation of Edward VII.

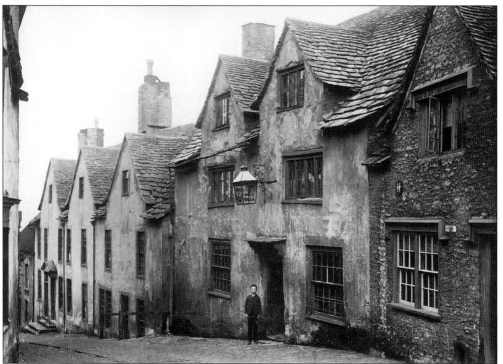

Famous for its strong beer, Frome had forty-two pubs in 1774. The Waggon and Horses in Gentle Street was a pub in the sixteenth century and closed its doors only in 1960. When this photograph was taken in about 1900, the ancient houses retained their stone tiles.

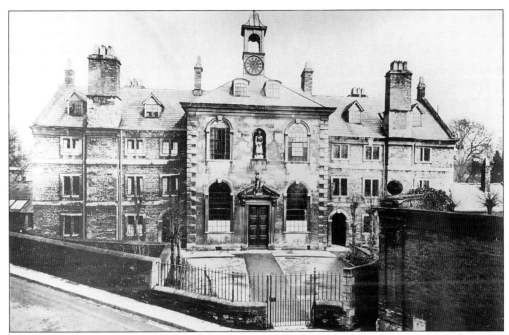

The Blue House, *c.* 1900. Completed in 1728 and a Grade 1 building of architectural and historic interest, the Blue House was both a school and an almshouse. The school occupied the centre, with its superior façade, until 1921. The building, now divided into flats for the elderly, derives its name from the blue tunics worn by the schoolboys.

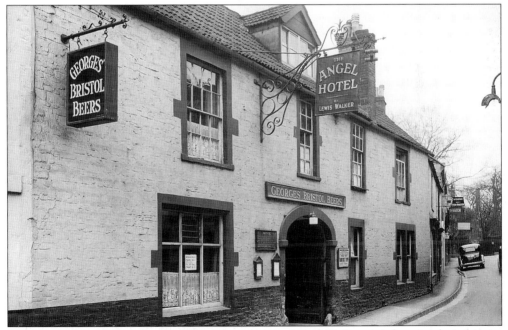

It has been claimed that the Angel Hotel was licensed in 1312; it certainly existed on this site in King Street, then known as Angel, or Back Lane, in 1665. When George's Brewery restored the inn during the 1950s, eighteenth century spade guineas were found beneath the floorboards of a sealed room.

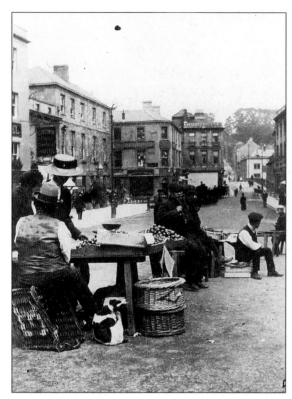

A glimpse of the Market Place on a quiet day, before cars were dominant, c. 1908. The apple seller's seat seems in danger of collapse!

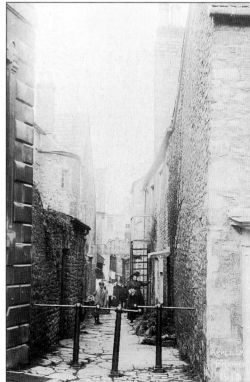

Apple Ally, redolent of old Frome, in 1909. It remains largely unchanged, narrow even by Frome standards, paved with irregular stone slabs, and overshadowed by high gables and tall chimneys.

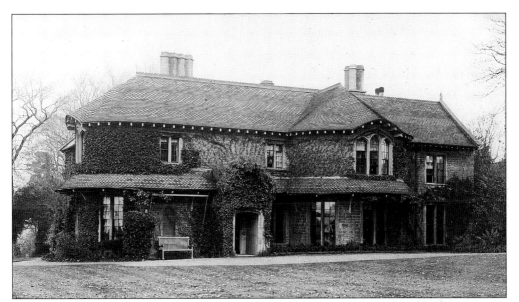

The Frome version of a cottage orné, Selwood Cottage (later Lodge) in 1912. This was built about 1820 by Charles Willoughby, a grocer, wine merchant and banker. He went bankrupt in the great crash of 1825. Once in the country, the house has since been encroached upon by expanding Frome.

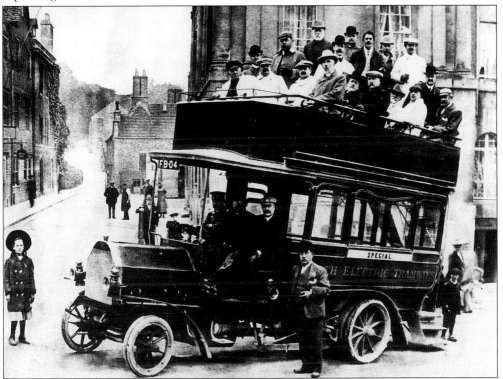

A Bath Electric Tramways omnibus outside the George Hotel Assembly Room c. 1906. On the left-hand side is Cork Street with a view of Hall House demolished in 1936. Reproduced by courtesy of Mr M.T. Tozer.

19

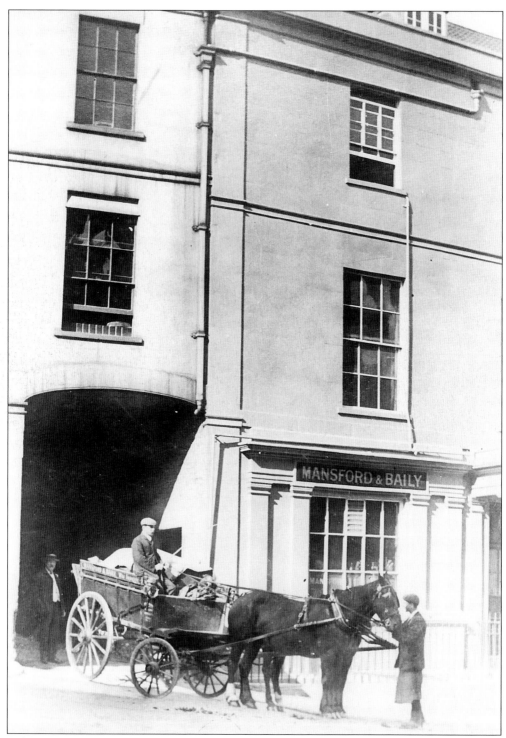

A horse and cart pause for the photographer on leaving the Wheatsheaves Inn in Bath Street. The inn is mentioned in 1731, but from 1870 was known as Mansford and Bailey's, a name still not entirely forgotten today.

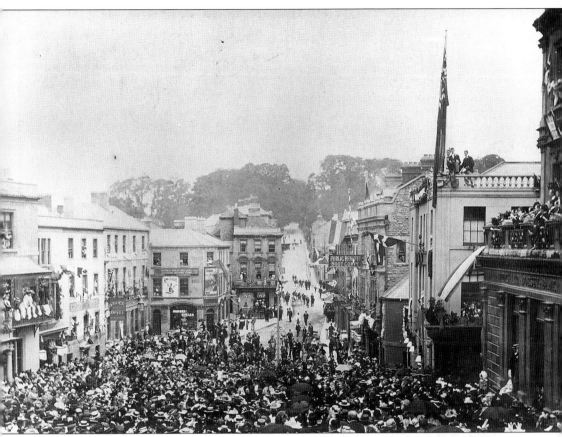

Frome people throng the Market Place to show their loyalty to the monarchy in June 1897. They are celebrating the diamond jubilee of Queen Victoria. The enthusiasm led to several practical schemes to benefit the town including building the Victoria Hospital, the Victoria Baths and the school of art.

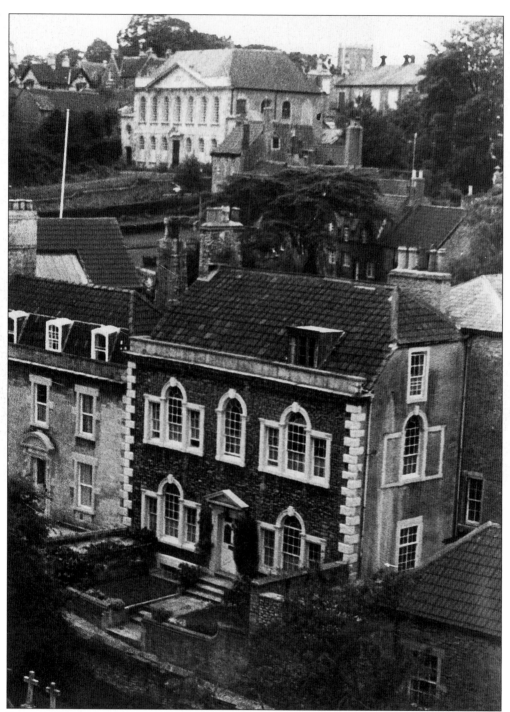

Some of Frome's architectural heritage seen from the tower of St John's church. In the foreground is Argyll House with its array of Venetian windows. It was built by Mary Jesser in the 1760s and is a Grade II listed building. Beyond is Rook Lane chapel, dated 1707 and one of the finest nonconformist places of worship in the west of England. On the horizon is the tower of Christchurch, erected in 1818. Reproduced by kind permission of Eunice Overend.

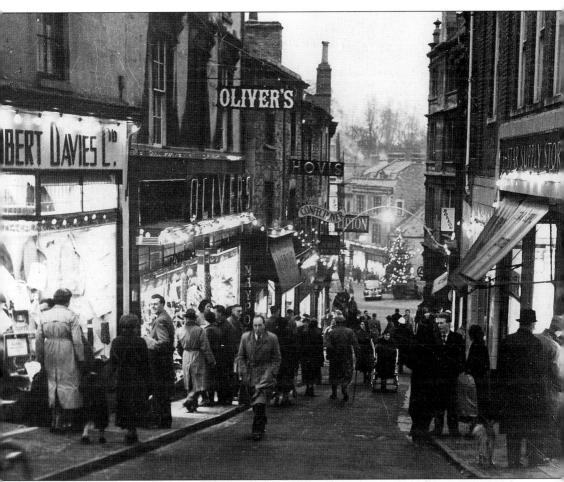

A festival fortnight held in Frome, which brought the town to life in 1956. This photograph shows the animated scene in Stony Street which contained popular shops such as Lipton's and Oliver's. Before the cutting of Bath Street from 1810, Stony Street was the main road out of the town to the south.

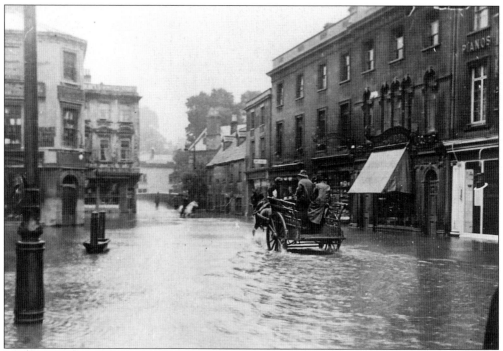

Until the flood prevention scheme of 1968, the river flooded on a regular basis and little was done about it. Here a horse and cart is the sole means of crossing the Market Place dry shod.

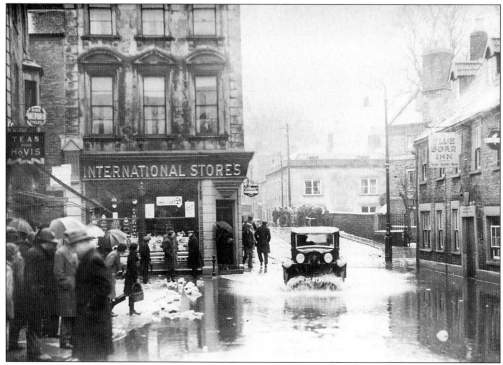

A car braves the flood waters about 1930. It passes the Blue Boar, built as an inn by Theophilius Lacey in 1691 and still in business today.

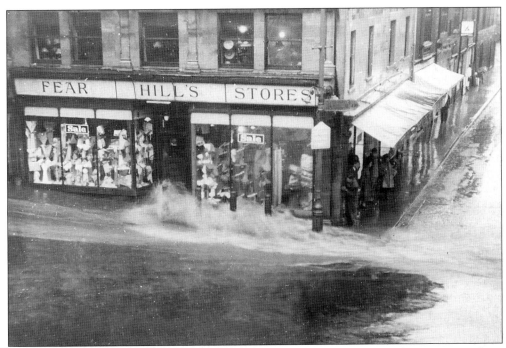

Water pouring down Stony Street after a storm in 1933. Fear Hill's was a famous Frome shop. The building was demolished in 1954.

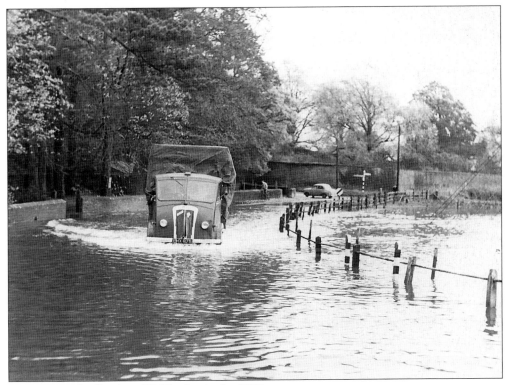

Negotiating the floods at Wallbridge in the 1950s.

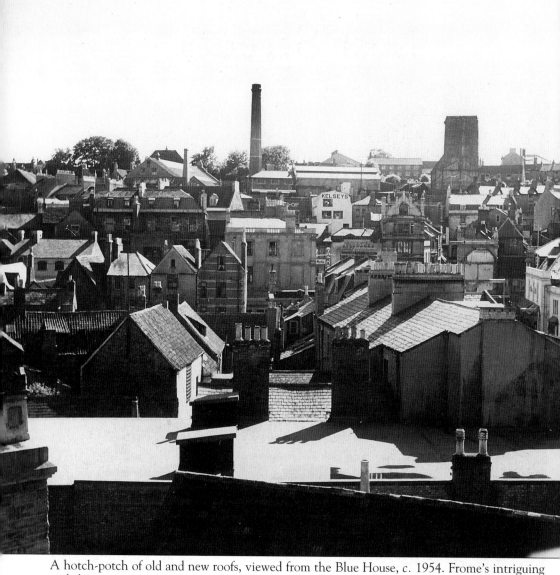

A hotch-potch of old and new roofs, viewed from the Blue House, c. 1954. Frome's intriguing and characteristic roofs climb the hillside in serried, but individualistic, ranks. Centre left is the backside of Cheap Street and centre right the George Hotel. On the skyline are the Lamb Brewery chimney and the Electricity Works tower, both taken down in the 1950s, so depriving the view of much of its drama.

Two

Lost Streets

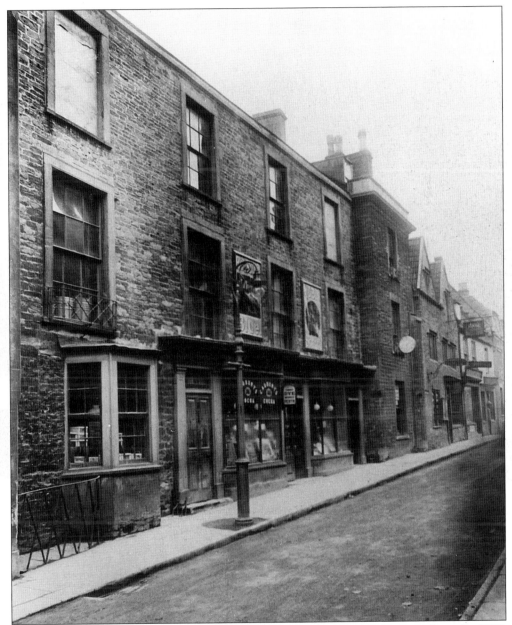

Palmer Street, with a mixture of stone-built houses typical of the local vernacular style, 1910. The street was redeveloped by the Co-op from 1923 with dire results, but its original charm and interest are apparent from this photograph.

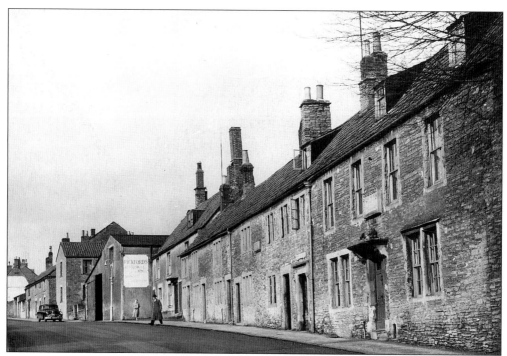

The north side of Broadway, approaching from Badcox, *c.* 1957. The handsome Georgian houses were demolished soon afterwards. The house on the right, with a carved stone lion athwart the hood above the door, was the Red Lion Inn.

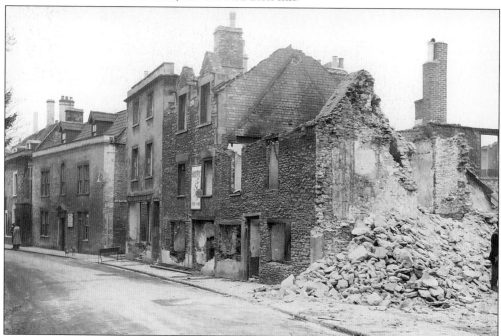

Bridge Street was once the main route out of Frome to the north and lined with houses and pubs including the Black Swan (left) and the Champneys Arms which was the London coach office. Most of the street was demolished in the 1950s to make way for the car park.

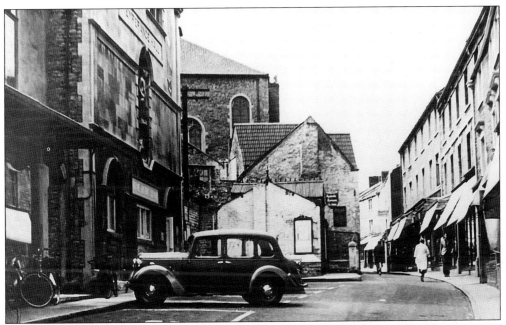

Looking up Catherine Street in the 1950s. On the left is the Temperance Hall with its statue of Hebe. It was designed and built by teetotallers in 1873 and demolished in 1964. The architect was the ubiquitous Joseph Chapman. Badcox Lane chapel still retained its art nouveau windows.

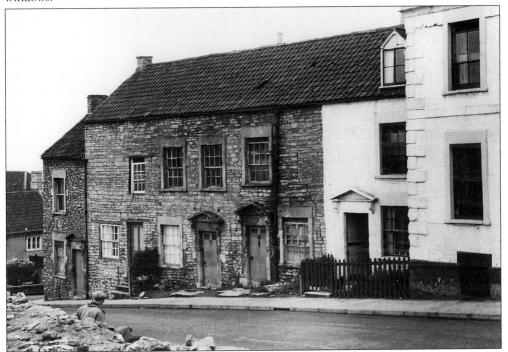

The robust charm of Gorehedge would now be admired and preserved but in the 1960s these handsome houses fell victims to road widening and general redevelopment. The name, which derives from the triangular shape of the land, was first recorded in 1487.

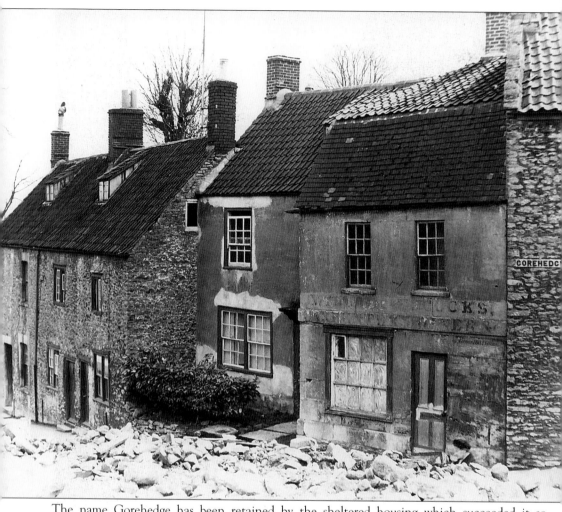

The name Gorehedge has been retained by the sheltered housing which succeeded it so providing continuity. The lower part, near Christchurch Street East, was known rather grandly as Greenhill Place and contained Hiscock's shop with a mansard roof.

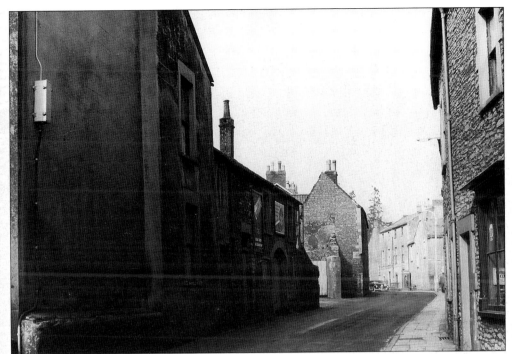

Vallis Way, looking up from Badcox, shortly before the left-hand side was demolished and rebuilt, 1958. A good example of the rather cavernous nature of many Frome streets.

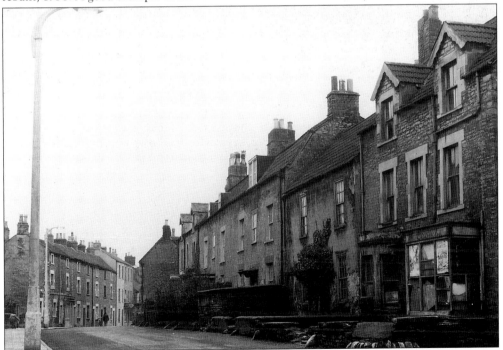

A further view of Vallis Way looking towards Badcox and showing the substantial houses that were taken down at the time, 1958. The shop on the right (Coomb's) marked the original corner of Horton Street.

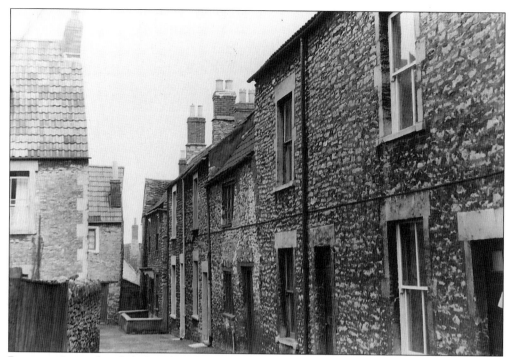

Rosemary Lane, shortly before demolition, in 1962. This was part of the Trinity area, one of the oldest groups of industrial housing in the country. Restored, it could have been a credit to the town.

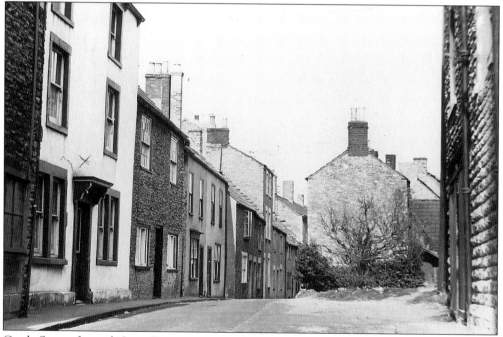

Castle Street, formerly Long Row, as it was in 1958. The three-storey white building on the left is the former Half Moon Inn. The right-hand side of the street, which marked the boundary of the Trinity area, was mostly levelled in the 1960s but rebuilt in traditional style in 1997.

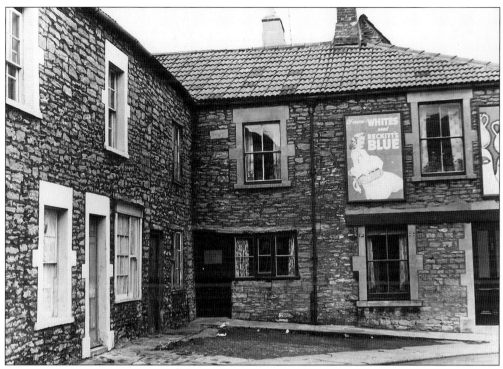

Characteristic Frome cottages built of Forest Marble and with 'eared' dressed stone window surrounds, at Milk Street corner. This attractive group, opposite Vallis First school, disappeared in 1963 as part of the 'great rebuilding' of the Trinity area.

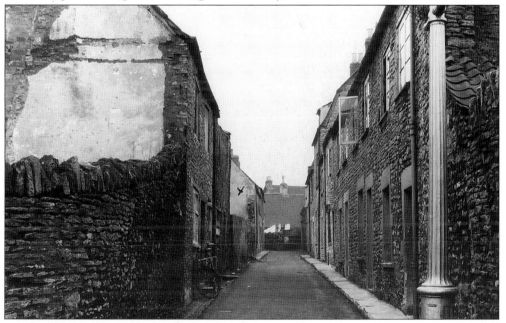

A typical Frome ally, Starve Acre, off Vallis Way, is marked on the 1774 map. It vanished in the clearances of the 1960s. Dorset Close took its place. The gap halfway up on the left was the site of a Presbyterian meeting house known as Bethel.

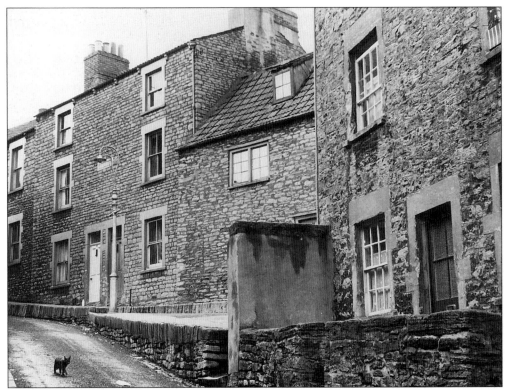

A cat crosses Fountain Lane, so-called from one of Frome's many springs which emerged here. The towering, tenement-like dwellings made way for council housing in 1963 which has, in its turn, been replaced this year.

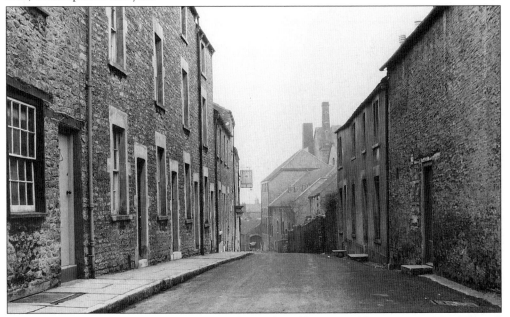

The right-hand side of Horton Street was also replaced by council housing in 1964. The tall building in the background is the United Brewery.

34

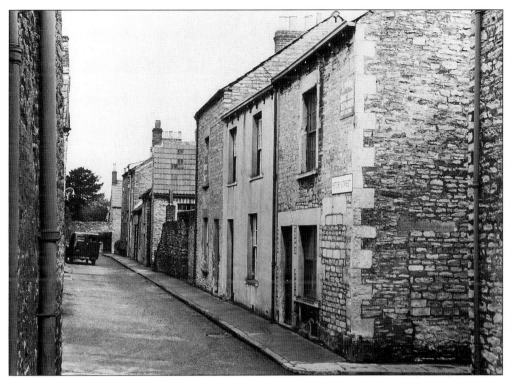

Peter Street, another vista lost to the bulldozer in 1963. The name, mentioned in 1827 as Peter's Row, is said to take its name from the saltpetre that was made there.

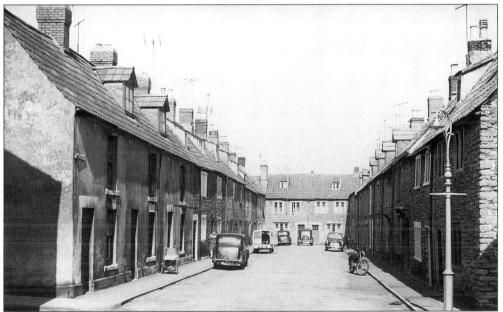

Due to a shortage of small change in the late-seventeenth century many leading merchants issued trade tokens in lieu. These were said to have been made in this street and to have given rise to its name The Mint. The name was retained by the development which replaced it in 1963.

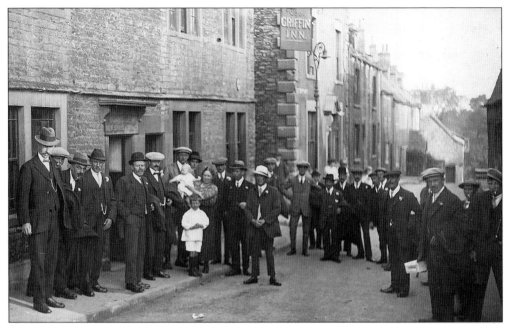

Dyer's Close Lane led down to the drying stoves at Low Water. The Griffin Inn has occupied this site since before 1774 and still remains but the houses beyond were cleared away and replaced by council housing. A postcard of the 1920s Frome folk, dressed in their best, awaiting a charabanc outing.

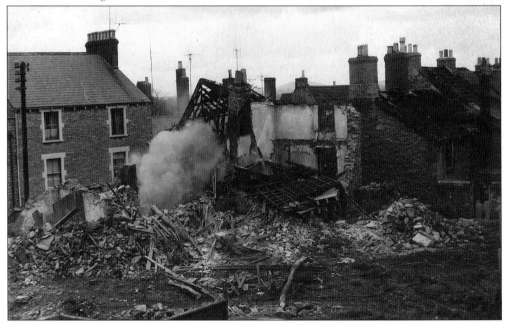

By the 1960s the Trinity area, nicknamed Chinatown, was in decline. The housing, some of which dated back to the late-seventeenth century, was sub-standard. According to prevailing fashion, demolition and replacement was preferred to restoration. Here the eastern end of Trinity Street bites the dust. Although this looks a thorough job of destruction, much of the street was retained.

36

Three
And Forgotten Buildings

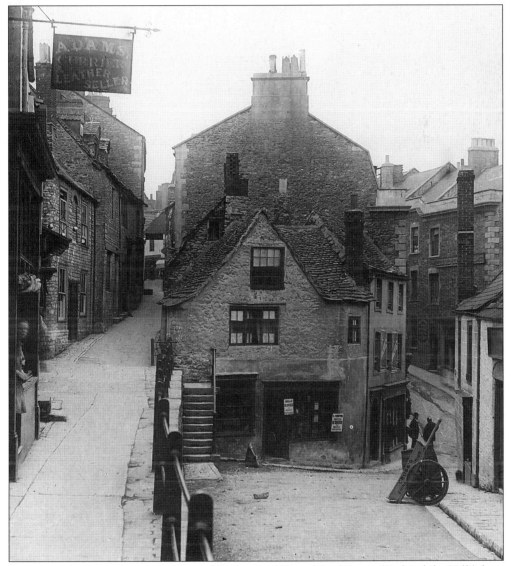

Immemorial calm, an evocative view of Catherine Hill and Paul Street ('Behind the Hill') from Palmer Street, *c*. 1888. The ancient stone-tiled cottages shelter under the tall Victorian façades. Barton's shop in the centre made way for an unglamorous public lavatory; the steps remain.

St John's school, Christchurch Street East, as it was in 1960. It stood on the site of the rectory (as opposed to the vicarage) and became a gentleman's residence leased out by Lord Bath. Remains of this house are on the right. The buildings were put to educational use as St John's College by the Revd W.J.E. Bennet in the 1850s and demolished in 1964/65.

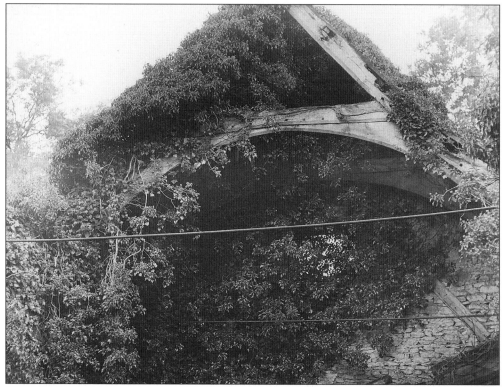

The Manor House of Frome was at Vallis, two miles outside the town on an escarpment above the confluence of the Mells stream and the Egford brook. Its outstanding feature was a fifteenth century open-timber roof seen here in 1974 in the last stages of decay. It has since been taken down.

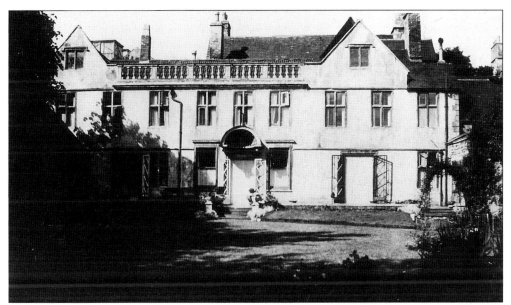

With its twin gables and imposing ten bay façade, Hall House in Cork Street was one of Frome's most distinguished mansions. It was the home of the Merchant family and the cross-windows suggest a mid-seventeenth century date. The shell hood was a later embellishment. Photographed in 1930, Hall House disappeared six years later.

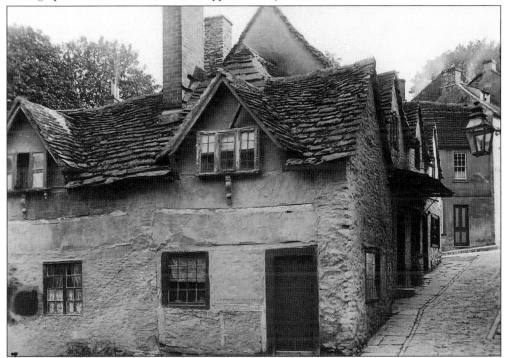

A source of pride and much photographed, these Elizabethan cottages at Gorehedge were, until their demolition about 1927, almost a symbol of the town. This did not save them from demolition, a public lavatory marks their site. The roadway, a continuation of Gentle Street and similarly paved with stone setts, continues towards Greenhill Place.

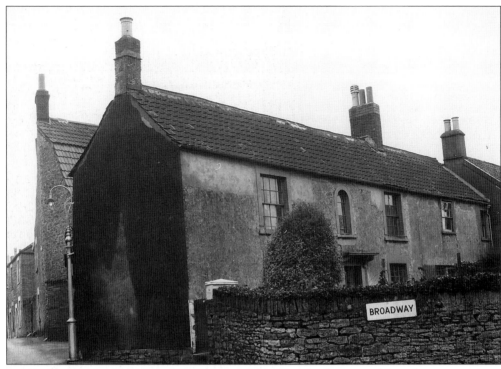

This Georgian house, making a brave attempt at classical symmetry, stood until 1960 on the south western side of Horton Street at its junction with Broadway. Beside it is one of the original standards for gas lighting made by the Frome firm of Cocky and Sons.

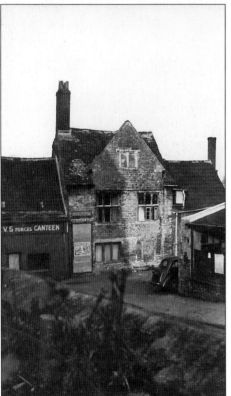

Although looking rather woebegone when this photograph was taken towards the end of the Second World War, 'The Old Vicarage' (a misnomer) was once among the best seventeenth-century buildings in Frome. It was demolished in 1970 when the road known as Saxonvale was created and its fine plaster ceiling carried off to Bradford-on-Avon.

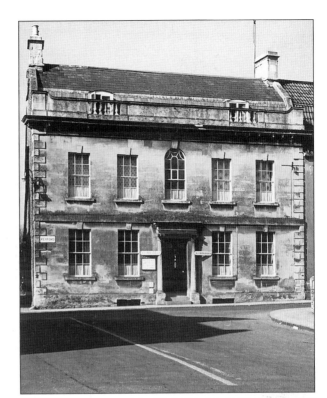

Georgian sophistication at High Place, on the corner of Keyford and Rossitter's Hill. This was one of Frome's best Georgian late-eighteenth century houses remarkable for the elegance and balance of its show front. It was a guest house before being razed to the ground for road widening in 1964.

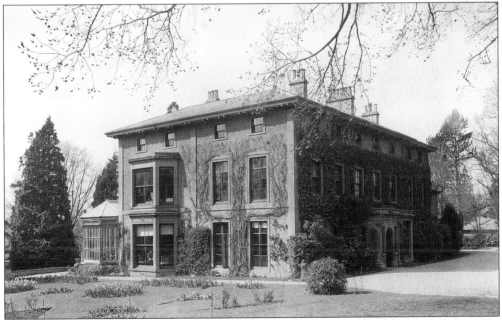

Only a generation separates the grace of High Place from the barracks-like solidity of East Hill House. East Hill was built by the Edgell family, rectors of Rodden (in which parish it lies) about 1825. It served as their private residence and was never the rectory. The mansion was bought from the Porters by Frome Urban District Council in 1936 and turned into flats. The walled garden survived demolition about 1964.

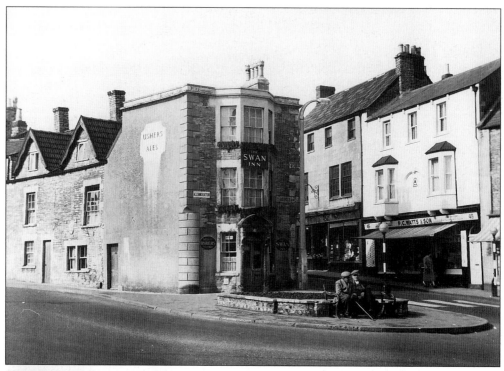

The Swan Inn, mentioned in the
church rates in 1663, was an
impressive feature of Badcox before
demolition to make way for a car
park in 1963. The late-Georgian
front with its three stories of
canted bay windows, masks
seventeenth-century gabled
buildings, a common arrangement
in economical Frome.

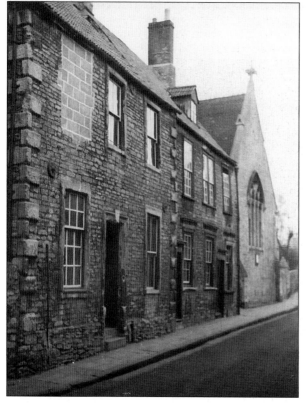

Georgian houses in Vicarage Street
also taken down for a car park in
1964. The house on the left was
the original post office. In 1860
deliveries began at 7a.m. in
summer and 7.30 in winter.

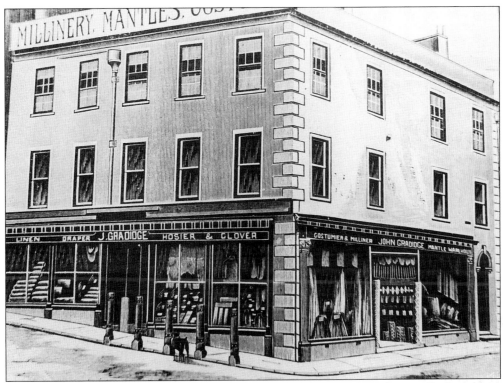

John Gradidge was Frome's leading linen draper in 1907. He operated not only from these spacious premises at No.3 Market Place but had also a large shop opposite at No.1 Bath Street. This shop is still remembered by older Frome people as Fear Hill's.

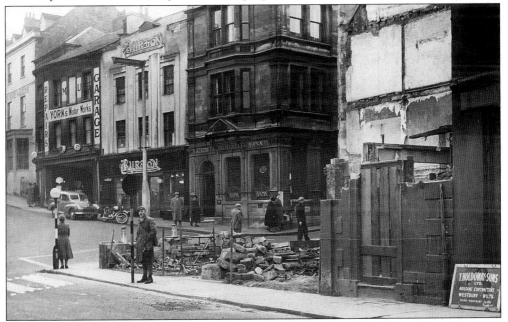

The last of Fear Hill's, the site after demolition in 1954. It was replaced by the present Pearl building. On the left are the premises of another vanished Frome business, York's Motor Works.

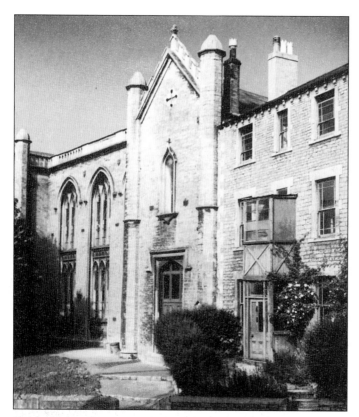

One of the more successful works of the Gothic revival in Frome was the National school in Bath Street. It was designed by a minor Bath architect, John Finden, in 1825 using a pleasingly unscholarly style. After lying derelict for many years, the building was demolished in 1974. On the right is the headmaster's house.

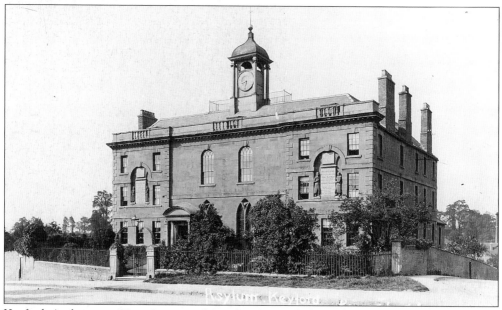

Keyford Asylum, or 'Home', a grand combination of classical and Gothic elements, was completed in 1804. It was given to Frome by Richard Stevens, a wealthy tanner, half as a refuge for twenty old men and half as an establishment where forty poor girls could be trained for service. This handsome building was demolished in 1956.

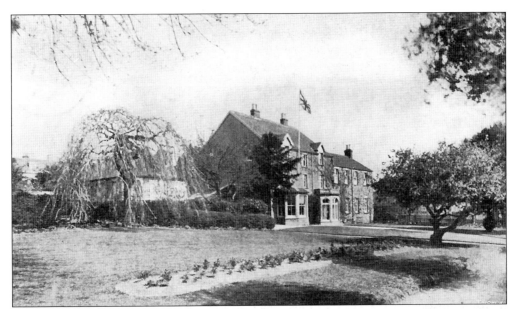

Keyford College, said in 1910 to be 'equipped with every modern improvement', was founded in 1806 and was one of the leading private schools in Frome. It continued to educate 'a good class of children' until the 1930s. The building, long since gone, was off Culverhill, opposite the asylum.

Griffin House, so named from the fabulous head emerging from the broken segmental pediment of the doorway, stands on the corner of Palmer Street and Bath Street. Once a fine early-eighteenth century house, it has been shorn of its imposing doorcase and other architectural glories.

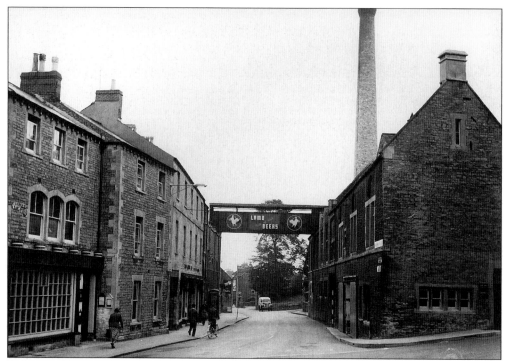

Frome was famous for its strong beer said to be preferred by the gentry to port or French wines. The Lamb was one of the leading breweries in the town with extensive premises at Gorehedge. This photograph of 1955 shows the bridge which linked the main building to an ancillary block across Christchurch Street East which still survives today.

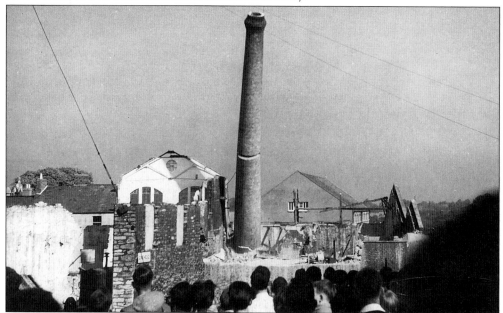

The Lamb Brewery was demolished in 1959 to allow for road widening. Here an unknown photographer has caught the dramatic moment when the chimney, a Frome landmark, was taken down.

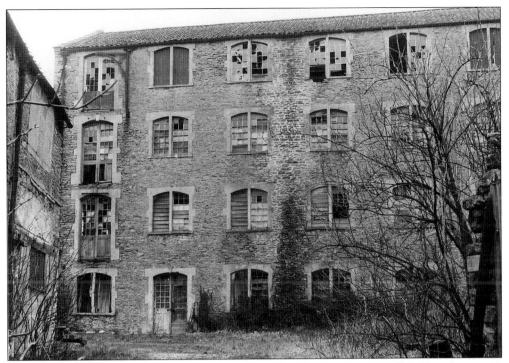

The other important Frome brewery was the United with premises off Vallis Way. Among its buildings it utilised Rawlings' old cloth factory, seen here in derelict condition shortly before demolition in 1959. Photograph by W.C. Pottrell.

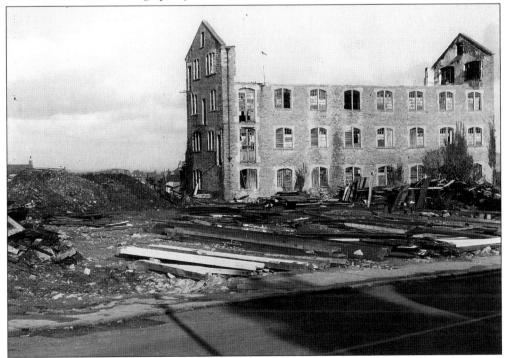

Rawlings' cloth mill in course of demolition from a photograph by Una Green.

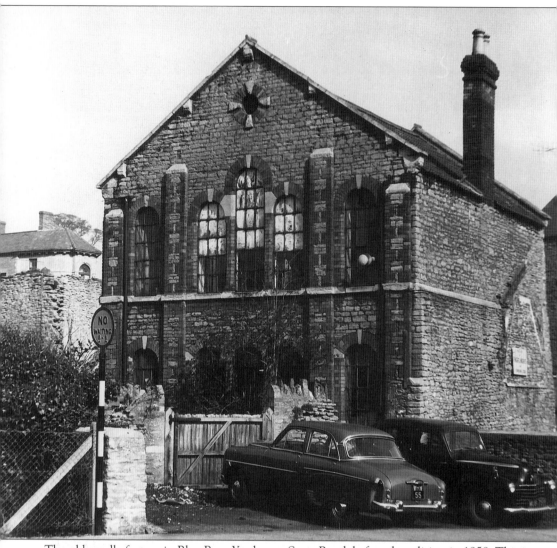

The old candle factory in Blue Boar Yard, now Scott Road, before demolition in 1958. This is a good example of the Byzantine style much favoured for industrial buildings in the mid-nineteenth century. In its last days it found a new use as the Band Room.

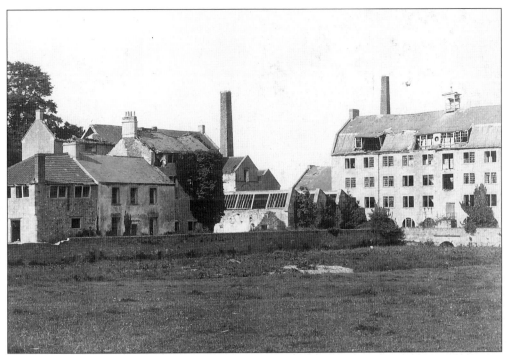

The Sheppard family, leading Frome clothiers, employed 1,000 people, in their heyday in the nineteenth century. Spring Gardens Mill, which closed in 1878, was their largest factory. The buildings, which rapidly became ruinous, were cleared away in the 1890s.

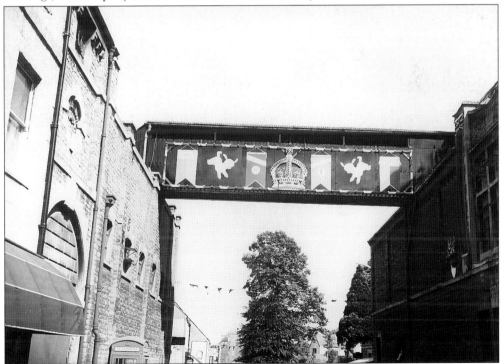

The Lamb Brewery bridge decorated in honour of the Queen's Coronation in 1953.

Greenhill Place looking towards Wesley chapel in the 1960s. Frome as it used to be with the way to Shepton Mallet looking more like a byway than a main road.

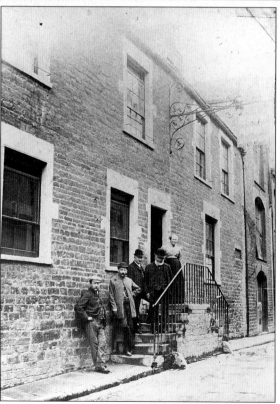

A group look towards the camera from the steps of the Bath Arms in Palmer Street c. 1910. The steps have now disappeared but the establishment still remains, now transformed from a pub to a restaurant.

Four
People

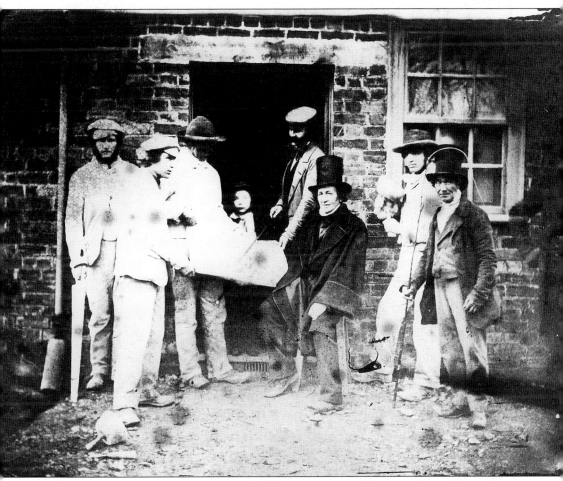

Orchardleigh House, 1856. It was built in 1856/58 to the design of Thomas Henry Wyatt. This rare photograph of the architect supervising the work was taken by the Revd W.A. Duckworth, the son of the house and a keen amateur photographer. This slightly posed group includes the clerk of the works, a coachman, and some of the building workers.

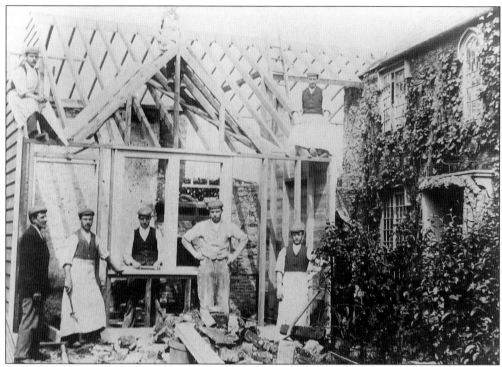

A group of builders at work about 1912. They pause briefly for the benefit of the camera. They are adding an extension to Ivy Cottage, now the Dowland Press, in Christchurch Street West.

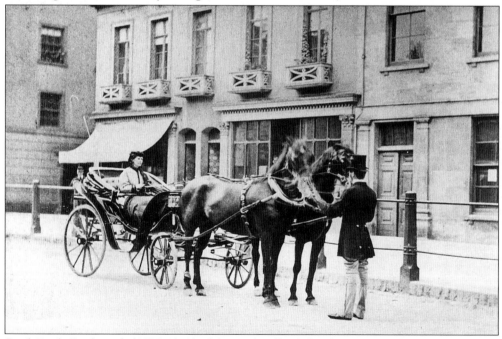

Sarah Emily Duckworth (1827-1918) of the Orchardleigh family, arrives at the Market Place in style, *c.* 1865. A liveried groom holds the horses' heads. The shops behind the phaeton remain, although much altered.

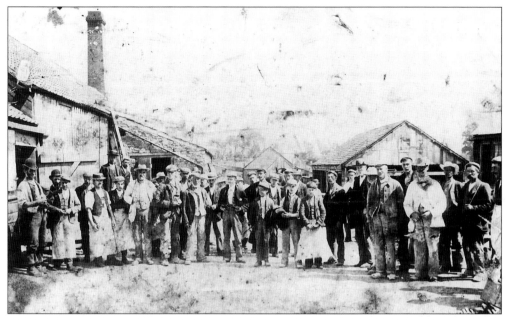

The building firm of F.J. Seward was founded in 1873 and continued to trade until 1966. The firm's yard was on Butts Hill where this impromptu gathering of workers was recorded about 1910. The chimney and some of the buildings remain.

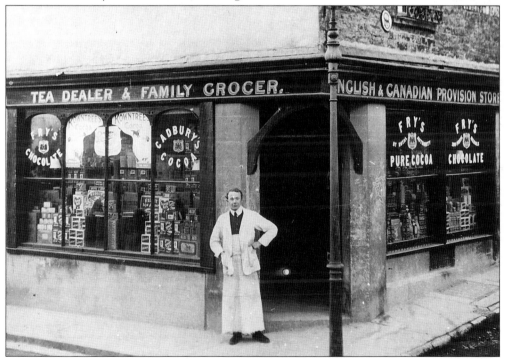

Charles Waters had several grocer's shops in Frome including this one at No.2 The Butts in the early 1900s. It stood on the corner of Somerset Road and is now demolished. The windows are well filled and Mr Anstey, the manager, stands at the front door ready to usher his customers inside.

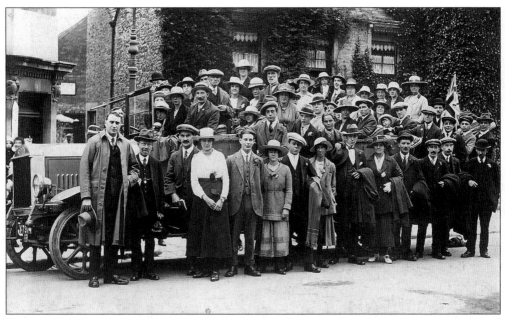

Frome seems always to have been a gregarious town with a penchant for meetings, outings and getting together generally. In the 1920s charabanc outings were particularly popular and this group is about to leave South Parade.

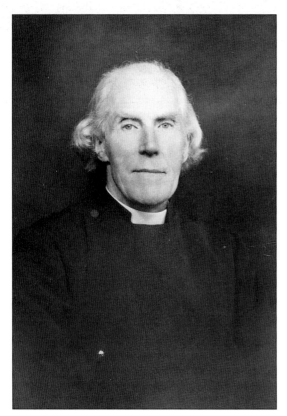

Prebendary W.F.H. Randolph was vicar of Frome from 1899 until 1938. He did much good work and was a parson of the old school, very much part of the local heirarchy. Vicar Randolph was much respected in Frome, the children's chapel of St Francis in St John's church being created to mark the fiftieth anniversary of his priesthood.

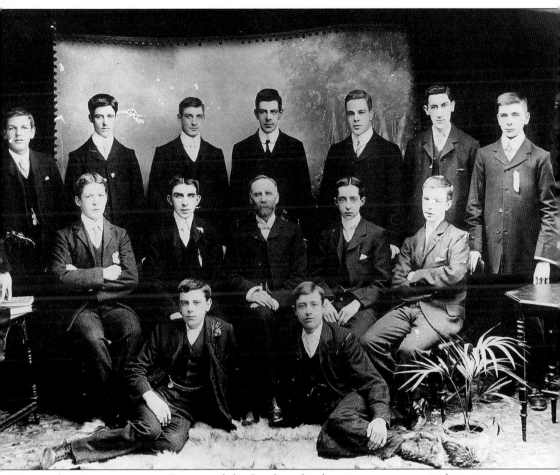

Nonconformity was strong in Frome and the Sunday school an important aspect of its mission. Frederick James Hodder (1863-1949) is seen here with the young men he trained up to be Sunday school teachers at Sheppard's Barton Baptist chapel. The group, taken about 1903, includes three other members of his family who were well-known as builders.

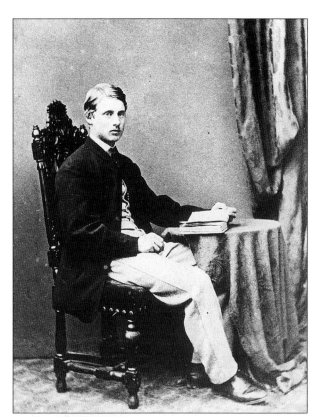

The Daniel family have provided Frome with clergymen and solicitors for nearly two hundred years. Revd Wilson Eustace Daniel succeeded his father, Alfred, as vicar of Holy Trinity and later became vicar of Horsington. He was an eminent local historian and pioneered the study of local place names. He died in 1924.

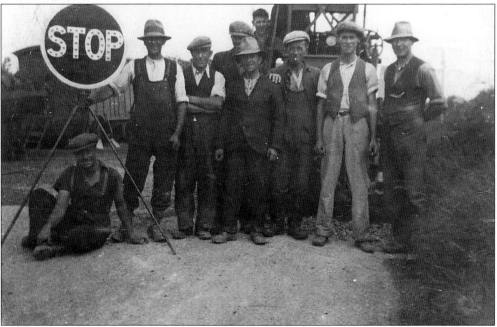

Local road workers enjoy having their photograph taken sometime during the 1930s. This gang worked for the Frome Rural District Council. On the right is Mr C.J. Smith, well-known resident of Gare Hill, who died in 2002.

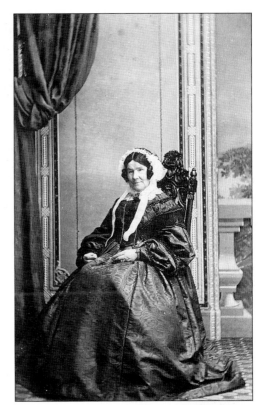

A portrait of businesswoman, Mrs Jane Sinkins, (née Hine) by F.C. Bird, *c.* 1865. She ran a successful draper's shop in the Market Place where the Midland Bank now stands. She was the mother of the Frome clothier and benefactor, John Sinkins, the builder of the Literary and Scientific Institute.

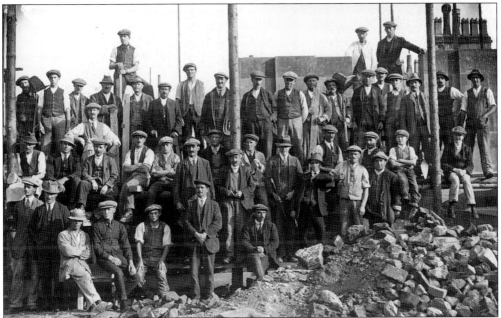

Mells Parks House was destroyed by fire in 1917. Sir Edwin Lutyens was called in to design a new mansion for Reginald McKenna, chairman of the Midland Bank. Here workers from the Frome firm of F.J. Seward take a breather from demolishing the ruins. Photograph by A.E. Whittington.

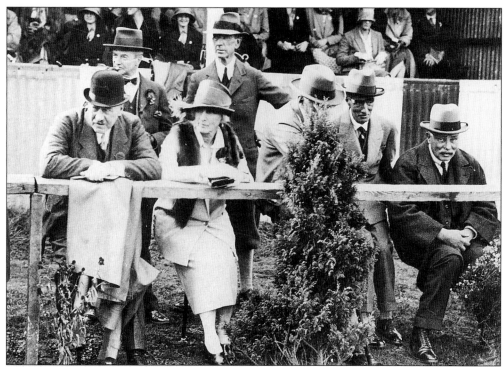

Frome Cheese Show started in a small way early in the nineteenth century but became a much larger affair from 1871. It always had the support of the great local landowners. Here Sir John Horner, the squire of Mells, his wife and friends, follow events in 1925.

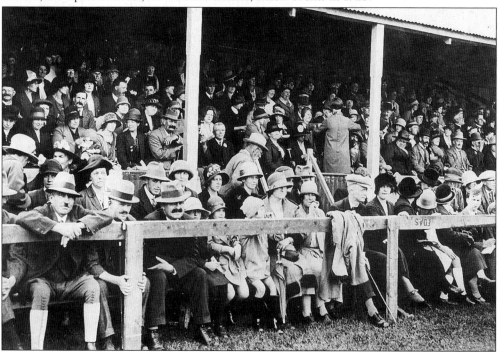

Part of the large crowd which attended the Frome Cheese Show in 1925.

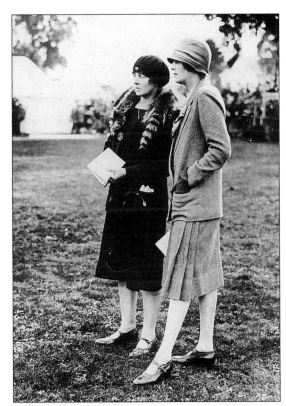

Two elegant young ladies at the Cheese Show in 1925.

Fashions for the more mature, two older ladies in conversation at the show.

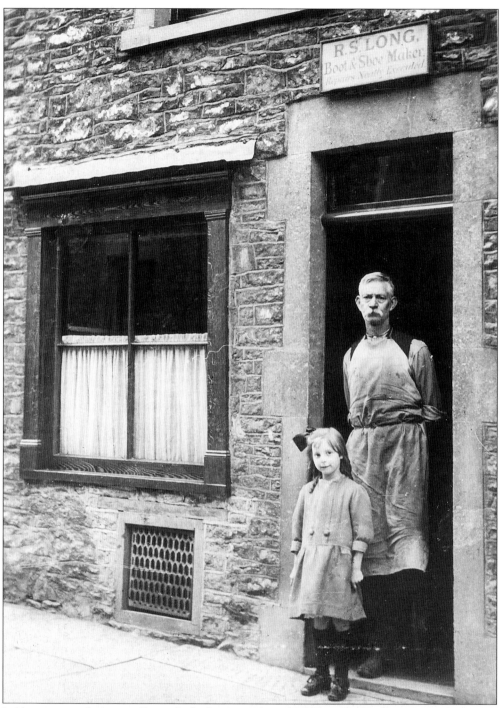

In the nineteenth century Frome had a huge number of cobblers. Richard Long, seen here with his daughter, who steals the show, was one of these. He was working from Fountain Lane in 1897, then moved to No.45, Selwood Road where this photograph was taken. He was still in business in the 1930s. The notice reads: 'R.S. Long. Boot and Shoe Maker. Repairs neatly executed'.

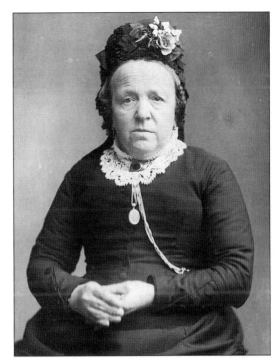

Mrs Jane Chapman (1820-1901), mother of seven. She was the daughter of Isaac Gregory, the famous constable of Frome, and wife of Joseph Chapman, Frome's leading architect and monumental mason. He courted her in verse.

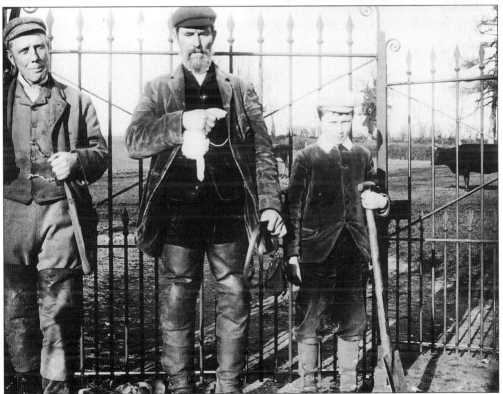

The gamekeeper on the Shore estate at Whatley. Holding the ferret with a firm and practised hand, he is about to set out with helpers for a spot of rabbiting.

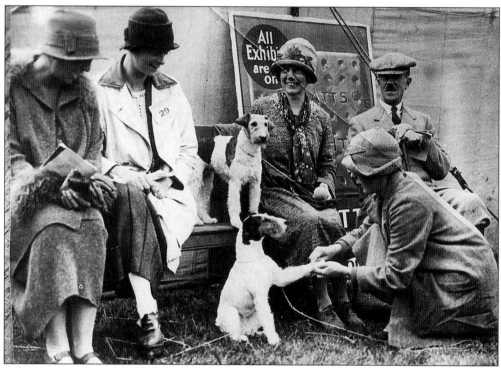

A group at Frome Cheese Show, making friends and breaking the ice in 1925.

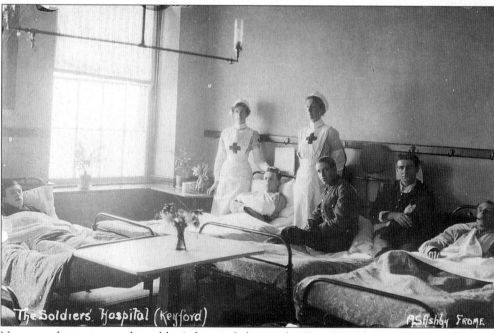

Nurses and patients at the soldier's hospital during the First World War. The hospital was housed at the Keyford Asylum and provides a rare view of the high, plain interior rooms. Photograph by Aldhelm Ashby.

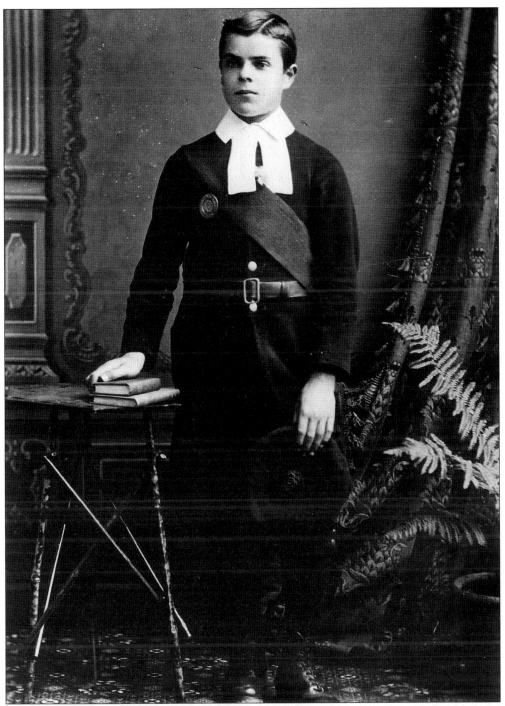

When the Frome almshouses were rebuilt in 1720, a blue coat school was incorporated and remained until 1921, when it merged with the Grammar School, now the Community College. This smart lad was a pupil at the Blue School about 1880 and wears the knee-length coat (with breeches) and carries a tam o' shanter cap with red pom pom. The boys in their uniforms were a distinctive element in the local street scene.

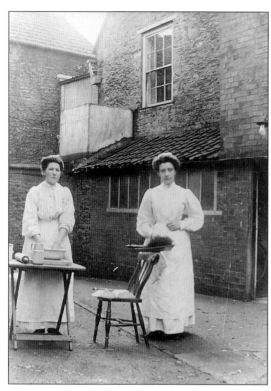

Staff at Rook Lane House, below stairs, take advantage of good weather to work outside, *c.* 1910.

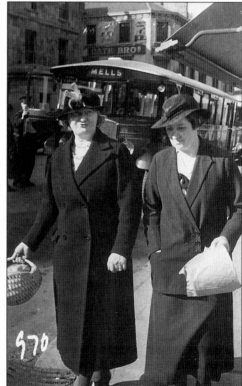

A delightful and unrehearsed scene in the Market Place frozen for ever by the camera, when ladies wore hats. The ladies go about their business in a stately and unhurried way while the Mells bus waits to depart.

Five
Recreation and Events

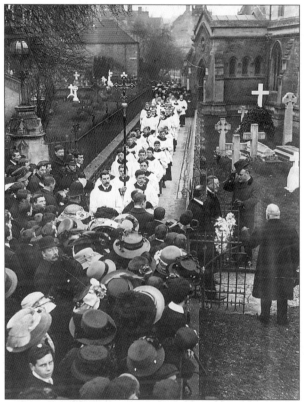

Thomas Ken, the hymn writer, was deprived of the Bishopic of Bath and Wells by William and Mary for his refusal to break his oath of allegiance to the deposed King James II. Ken retired to Longleat. He died there in 1711 leaving instructions to be buried in the nearest churchyard of his former diocese. The honour fell to Frome which has always respected his tomb. Elaborate ceremonies marked the bi-centenary of his death. These took place at St John the Baptist's Church on 19 March 1911. Here the choir is processing to the tomb, led by the churchwardens and singing *Brief Life is here our portion*.

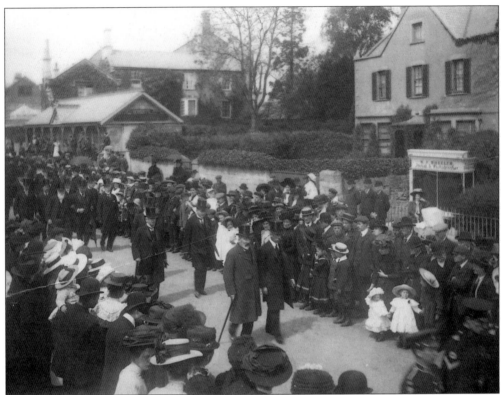

The memorial procession for Queen Victoria passes Stoke House in Christchurch Street West in January, 1901. Everyone wears some black in token of mourning. Top left is Short's Carriage Works and behind them Southill House demolished after the First World War to make way for the memorial hall.

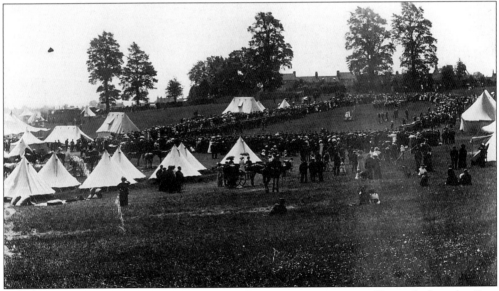

Church parade at a North Somerset Imperial Yeomanry camp near Frome before the First World War.

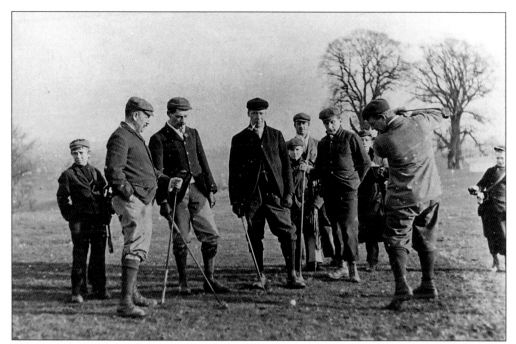

There was a golf club in Frome which functioned on The Leys in 1900. It was established under the aegis of Revd John Polehampton, vicar of St Katherine's in the Woodlands. The golfers are thought to be, from left to right: Dr Dalby, Robert Gordon of Fromefield, Revd J. Polehampton, Revd E.D. Lear, Rector of Mells, and Arthur Polehampton.

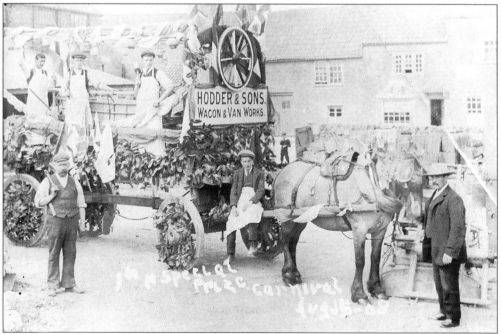

There was great competition amongst traders to provide the best decorated floats in the annual carnival procession. Hodder & Sons, Wagon and Van Works, entered this horse-drawn float in 1908. The men proudly hold the implements of their trade.

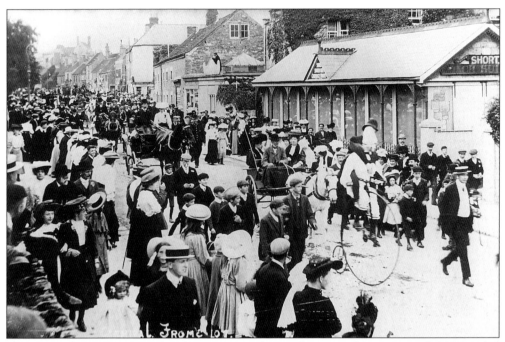

An animated scene in Christchurch Street West during the carnival procession of 1907. It is led by a clown on a penny-farthing.

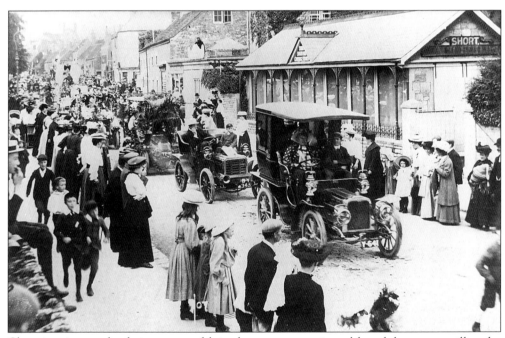

Changing times make their presence felt in the same procession, although horses are still to the fore, a cavalcade of motor vehicles makes a striking impression.

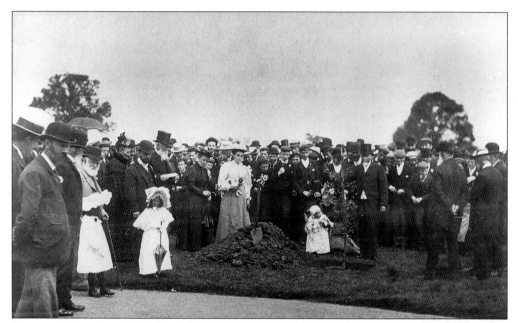

Victoria Park in June 1897. Frome's great and good gather to plant an oak tree to commemorate the diamond jubilee of Queen Victoria. The children are dressed to the nines, no one seems anxious to tackle the large heap of soil.

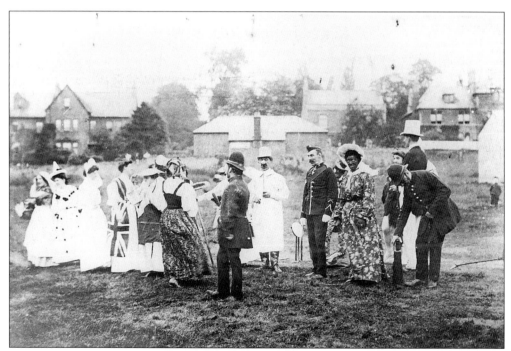

A droll scene in a field in front of West End in 1907. A fancy dress cricket match is about to take place. On the left are Henley Villas, demolished in the 1970s.

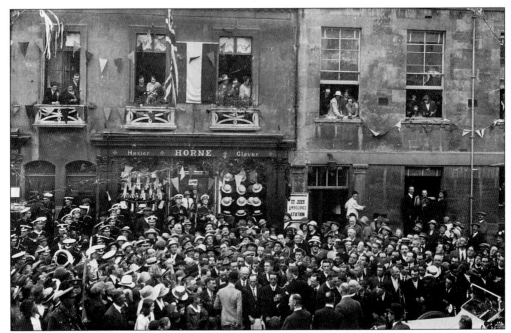

The Prince of Wales, later King Edward VIII, passed through Frome when visiting the local estates of the Duchy of Cornwall, June 1923. An enthusiastic crowd gathered in the Market Place where the Prince greeted ex-servicemen. He is the figure in the bowler hat and light suit with his back to the camera. Charles Horne was a hosier, glover and general outfitter.

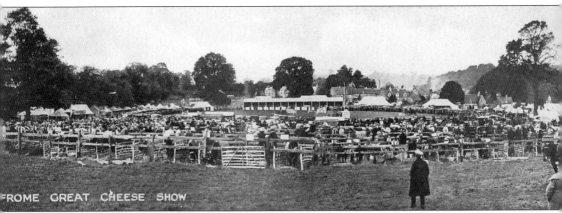

This panorama of the Cheese Show was taken by A.E. Whittington, one of the most talented photographers in the 1920s. It was used by Lovatt's, the chemist in Bath Street, as a Christmas card.

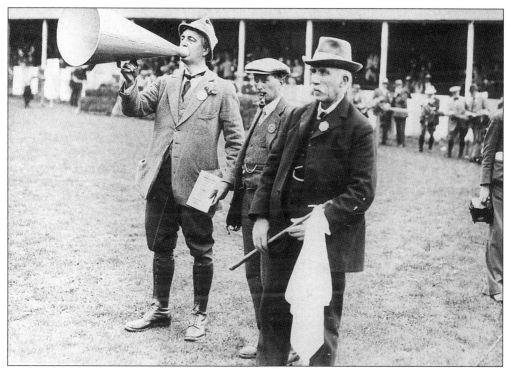

Before loudspeakers, an announcement is made at the Cheese Show with a megaphone while officials wait to go into action, *c.* 1925.

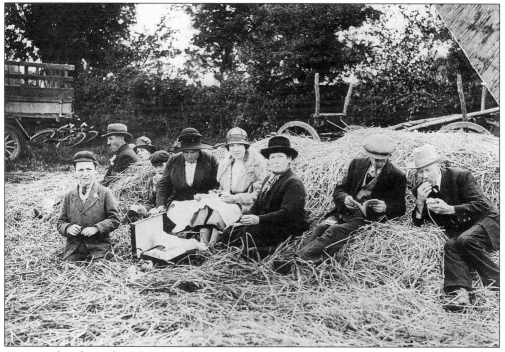

A picnic lunch at the Cheese Show, *c.* 1925. The participants look at the camera slightly askance.

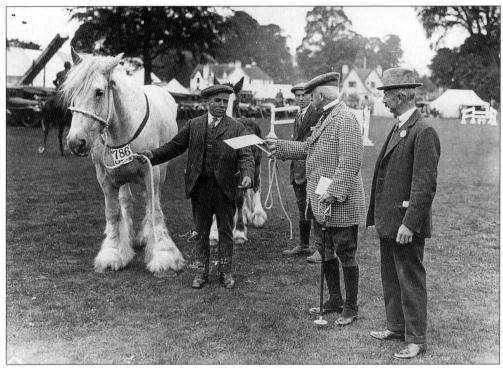

Prize-giving, satisfactory for the pleased owner but a bit of a bore for the blasé horse.

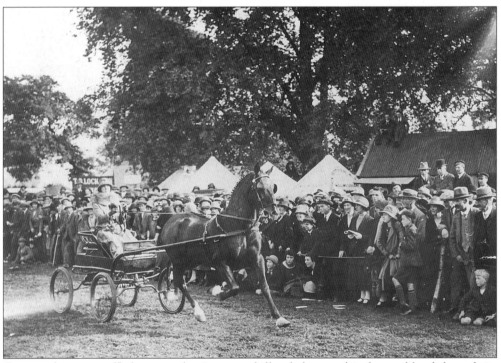

Carriage driving, muffled against the Autumn chill, a lady puts this thoroughbred through its paces at the Cheese Show in 1925.

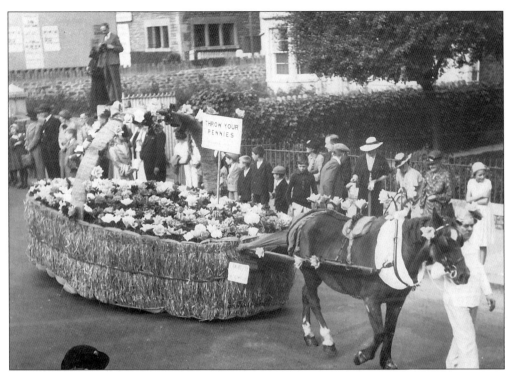

Frome people open their purses during a carnival procession, *c.* 1930. This float, arranged as a basket of flowers, passes Stoke House in Christchurch Street West.

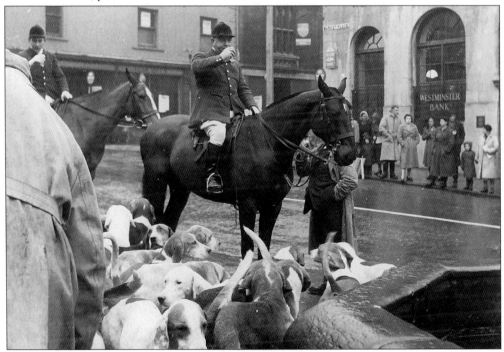

The South and West Wilts Hunt holds its boxing day meet in the Market Place, *c.* 1953. In the background is Fear Hill's shop demolished soon after this photograph was taken.

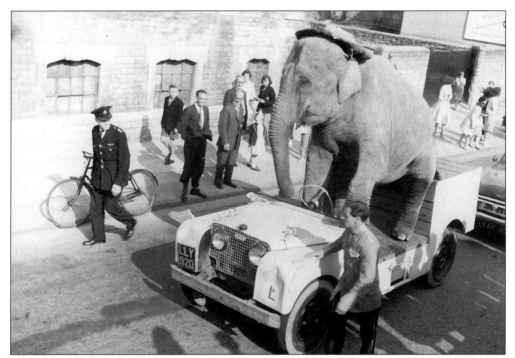

An elephant driver in Christchurch Street East when the circus came to town, c. 1955. The policeman looks on, disapprovingly.

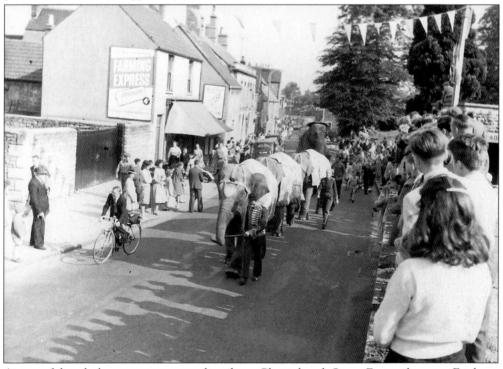

A view of the whole procession proceeding down Christchurch Street East and passing Fairlawn House.

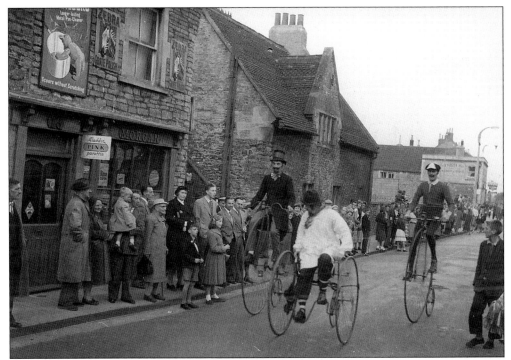

The tail-end of the procession as two penny-farthings and a tricycle pass the now demolished Morgan shop in Christchurch Street East. In the background are the remains of the former St John's College.

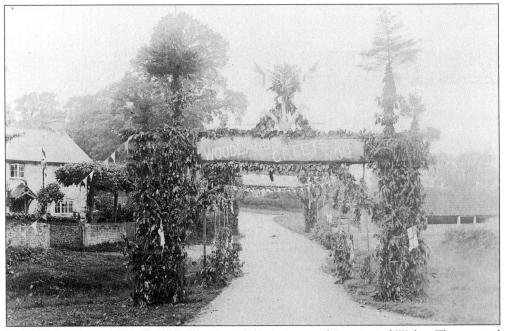

Decorations at East Woodlands in honour of the Prince and Princess of Wales. They visited Longleat in 1909 and drove through the hamlet on their way to Frome station. On the left is the Horse and Groom Inn.

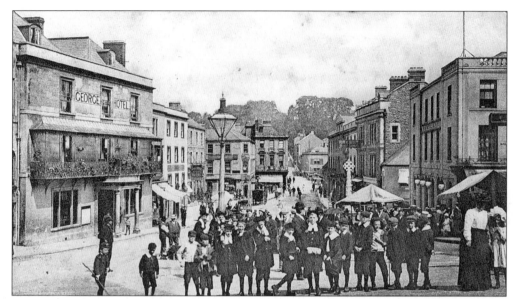

Blue School boys in uniform gather in the Market Place in 1906. Besides the Boyle Cross, there is also a handsome lamp standard in the middle of the area.

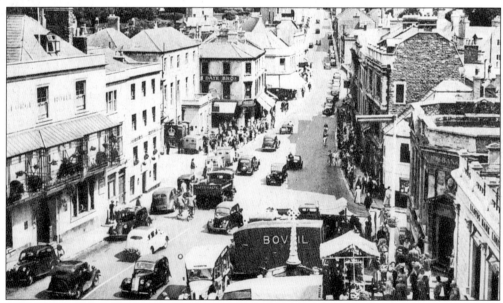

A busy scene on market day sometime in 1956. In fifty years some buildings have been replaced and the George has lost its porch but the changes are cosmetic rather than fundamental.

Six
Industry and Commerce

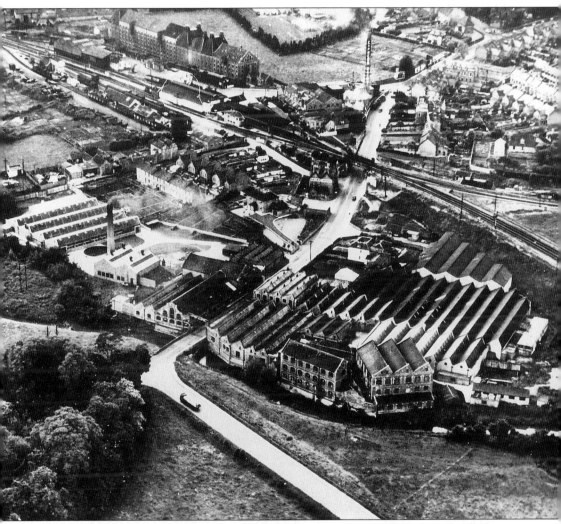

A bird's eye view of an industrial town, c. 1950. Frome was a centre of the woollen industry from the fourteenth century. Wallbridge Mill (on the right by the river) was the last mill to close in 1965. Some of the heavy cloth coats made there are still in wear. In the top left are The Maltings, erected by Baily's in 1896 to serve Frome's breweries, and demolished in the 1960s. In front of The Maltings is Frome station with its Brunelian overall roof.

Stimulated by the Great Exhibitions of the day, Frome held its own 'Art and Industrial Exhibition' in 1866. This is a rather tantalising glimpse of the art display in the Auction Mart.

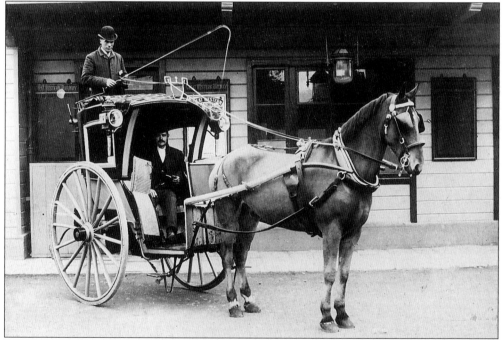

A fleet of hansom cabs ferried the alighting passengers from Frome station to the Market Place, c. 1900. Frome station was opened in 1850 allowing train travel to London. The building looks well cared for.

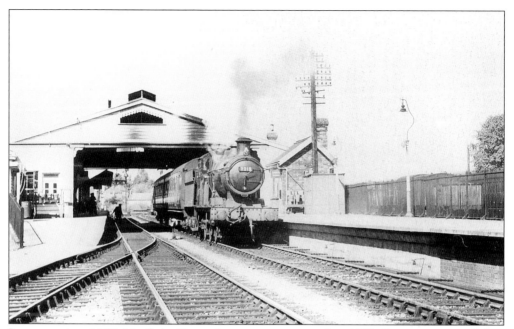

Frome station, 1957. Until the Frome loop was constructed in 1933, Frome was a main line station. Here we see it with its 'up' and 'down' lines and the overall roof designed by J. Hannaford, one of Brunel's assistants. It is one of the few still used for its original purpose. Photograph by H.B. Priestley.

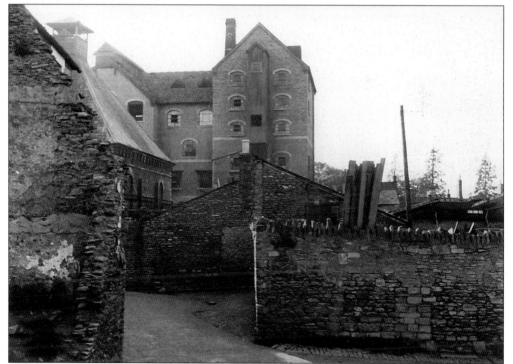

The United Brewery buildings before demolition in 1959. Their height and solidity dominated the area between Vallis Way and Badcox.

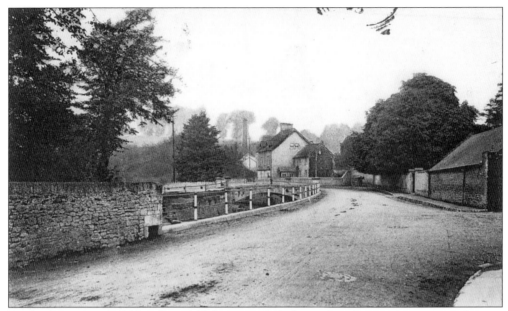

A peaceful scene at Welshmill in 1905. It seems idyllic but in fact the river here provided power for one of Frome's leading cloth mills.

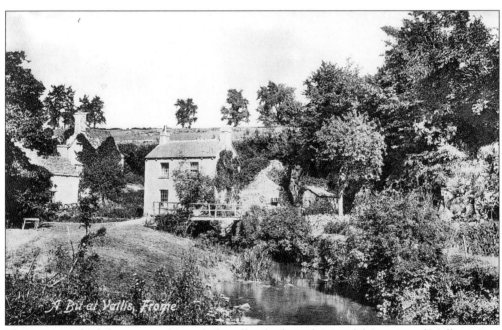

The ruins on the left are one of two cloth mills which made use of the waters of Mells stream. Riffords Mill shown here was nicknamed Bedlam, certainly derogatory but also perhaps denoting its remoteness from the town.

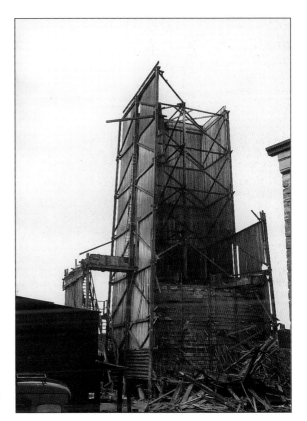

One of the wooden towers of the Electricity Works in the course of demolition. This was an eye catching feature on the local skyline until it was taken down in the 1950s.

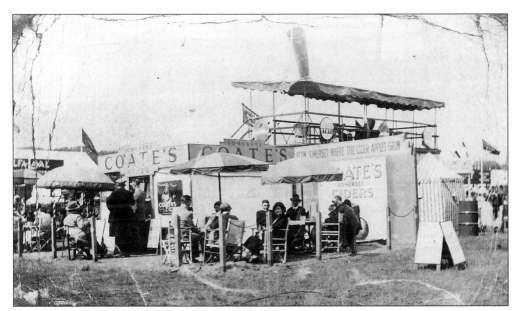

Coates's Somerset cider makes its presence felt at the Cheese Show, c. 1930.

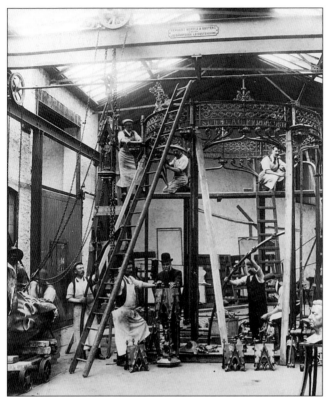

John Webb Singer, who described himself modestly as a brass founder, founded his firm in 1848. He started off making candlesticks and other ecclesiastical ornaments and evolved into one of the leading statuaries in the United Kingdom. *Boadicea* on the Thames Embankment is the best known of his many national statues. Here, in 1902, his workers exhibit the versatility of the firm.

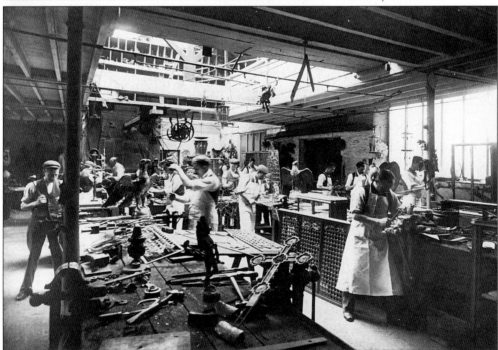

Another view of Singer's workshops in action. The statuary business was sold off in 1926 but the firm still makes brass pressings in Frome.

Robert Bennett's polite trade card, c. 1914.

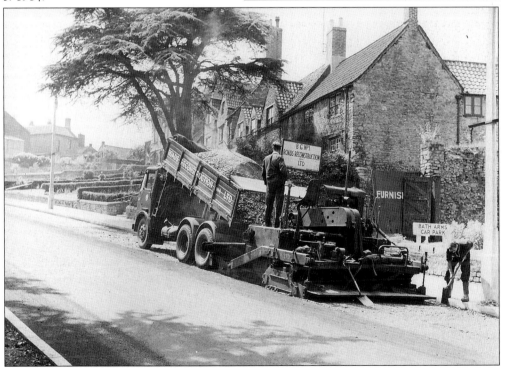

Resurfacing Bath Street in the 1950s. Although Bath Street seems steep enough today, the gradient has been much reduced since it was first cut in 1810.

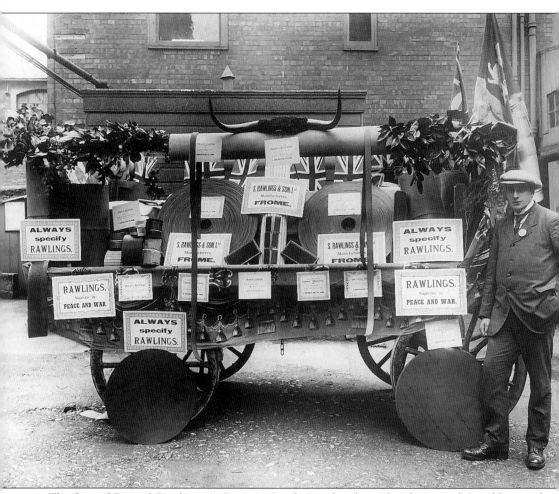

The firm of Samuel Rawlings & Sons, in South Parade, claimed to be one of the oldest card manufacturers in the west of England. Cards (from the Latin for teasel) were implements of wood or leather covered with teasels or, later, wire. These were used to open and mix wool. Rawlings also made leather straps and belting. Women and children were used to make cards and in its great days, Rawlings employed five hundred of them in the work. The firm closed in 1972 after an existence of three hundred years. This float, advertising the company's products, was used in the carnival procession.

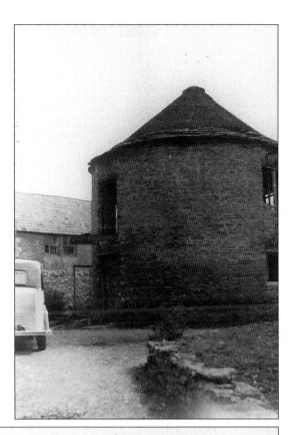

The 'Round Tower', as it is called, was a stove used to dry dyed cloth and an interesting relic of Frome's industrial past. It probably dates from the late-eighteenth century. This photograph of 1935 shows the original roof, later removed to save repairs. In 1995, the tower was well restored as a local information office.

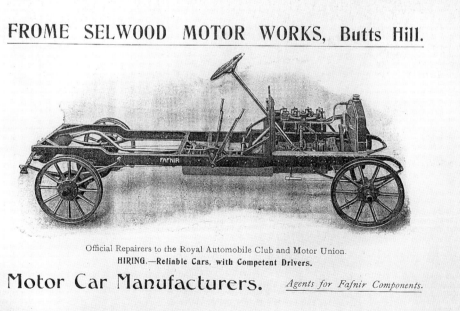

FROME SELWOOD MOTOR WORKS, Butts Hill.

Official Repairers to the Royal Automobile Club and Motor Union.
HIRING.—Reliable Cars, with Competent Drivers.

Motor Car Manufacturers. *Agents for Fafnir Components.*

Frome quickly took to the internal combustion engine and the 'Achilles' motor car was made by the Frome Selwood Motor Works in Butts Hill by 1903. An example in working order is still preserved. This rather uninviting advertisement is from a town guide of 1907.

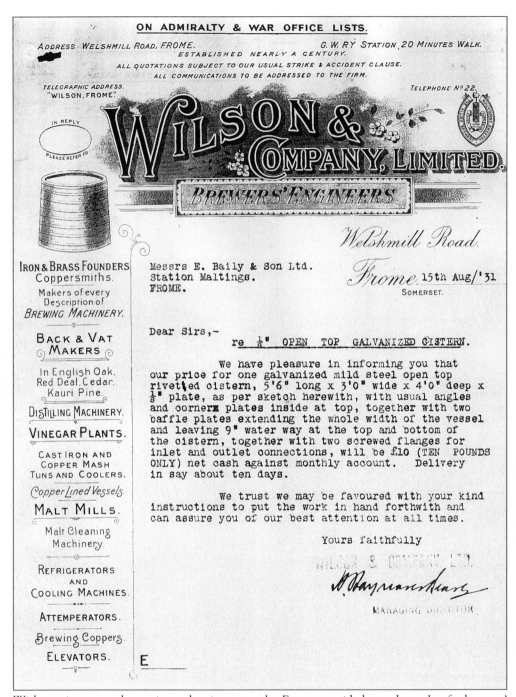

ADDRESS WELSHMILL ROAD, FROME.　　　　　G. W. RY STATION, 20 MINUTES WALK.

ESTABLISHED NEARLY A CENTURY.

ALL QUOTATIONS SUBJECT TO OUR USUAL STRIKE & ACCIDENT CLAUSE.

ALL COMMUNICATIONS TO BE ADDRESSED TO THE FIRM.

TELEGRAPHIC ADDRESS.
"WILSON, FROME."

TELEPHONE N° 22.

IN REPLY
PLEASE REFER TO

WILSON & COMPANY, LIMITED.
BREWERS' ENGINEERS

IRON & BRASS FOUNDERS.
Coppersmiths.
Makers of every
Description of
BREWING MACHINERY.

BACK & VAT MAKERS

In English Oak,
Red Deal, Cedar,
Kauri Pine.

DISTILLING MACHINERY.

VINEGAR PLANTS.

CAST IRON AND
COPPER MASH
TUNS AND COOLERS.

Copper Lined Vessels.

MALT MILLS.

Malt Cleaning
Machinery.

REFRIGERATORS
AND
COOLING MACHINES.

ATTEMPERATORS.

Brewing Coppers.

ELEVATORS.

Welshmill Road.

Frome, 15th Aug/'31
SOMERSET.

Messrs E. Baily & Son Ltd.
Station Maltings.
FROME.

Dear Sirs,-

　　　　re ⅛" OPEN TOP GALVANIZED CISTERN.

　　　　We have pleasure in informing you that
our price for one galvanized mild steel open top
rivetted cistern, 5'6" long x 3'0" wide x 4'0" deep x
⅛" plate, as per sketch herewith, with usual angles
and corner plates inside at top, together with two
baffle plates extending the whole width of the vessel
and leaving 9" water way at the top and bottom of
the cistern, together with two screwed flanges for
inlet and outlet connections, will be £10 (TEN POUNDS
ONLY) net cash against monthly account. Delivery
in say about ten days.

　　　　We trust we may be favoured with your kind
instructions to put the work in hand forthwith and
can assure you of our best attention at all times.

　　　　Yours faithfully

　　　　WILSON & COMPANY LTD.

　　　　MANAGING DIRECTOR.

E

With two important breweries and a vinegar works, Frome provided a ready market for brewers'
engineers. Wilson & Co. succeeded Oxley & Geoghegan, of Welshmill, before 1883. Their
note paper offers a tempting range of services. As Wilson & Scotchman, the firm survived into
the 1960s at Keyford.

Seven
Orchardleigh and Lullington

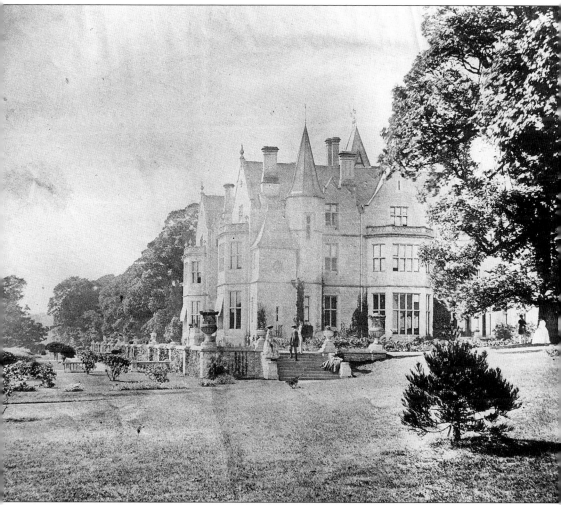

Commanding a splendid view, the new Orchardleigh House replaced the medieaval manor of the Champneys family in the valley below. It was built for William Duckworth, a Lancastrian lawyer and successful land speculator, between 1856 and 1858. Duckworth wanted an unpretentious and comfortable home but his architect provided a 'Tudorbethan' house with French renaissance elements. The photograph, taken in 1862, comes from the album of Revd and Hon. R.C. Boyle, Rector of Marston Bigot, and shows the pristine house amid recent plantings.

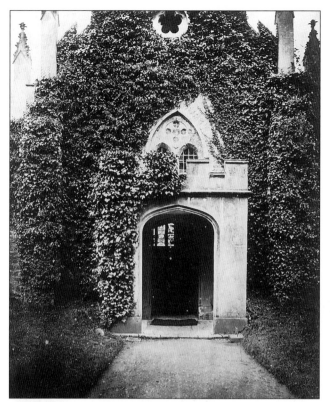

Although genuinely old, the church of St Mary the Virgin, Orchardleigh, was embellished with pinnacles and battlements in the early-nineteenth century. It became an ivy-green object in the landscape. Pinnacles, porch, cinquefoil window and the entire western entrance were swept away in 1879 when the church was restored according to a scheme drawn up by Sir George Gilbert Scott before his death.

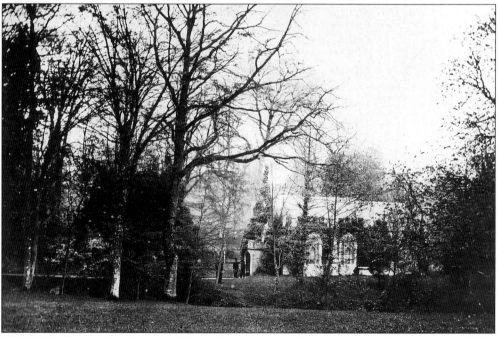

Old Orchardleigh church, viewed from the north and showing its battlements and western porch, 1878. The dip in the foreground hides the moat dug round the building by Sir Thomas Champneys around 1800.

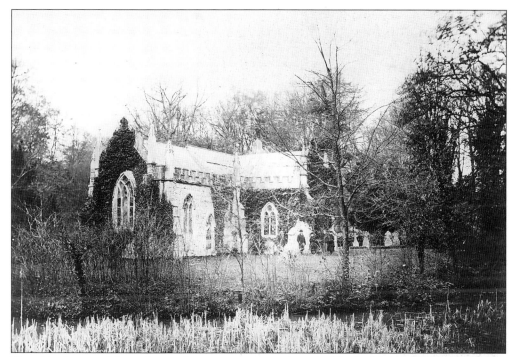

The church viewed from the north-west giving a good view of the building before restoration in 1878. At the time it was considered an example of 'debased Georgian Gothic' but to us has more life and charm than the later, more formal, versions of the style.

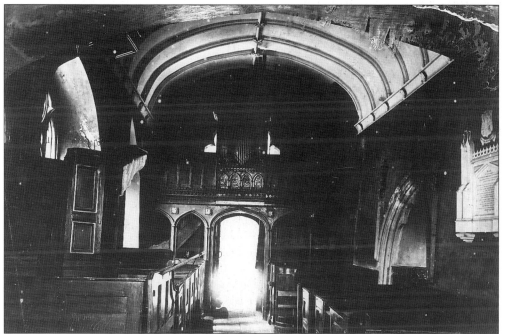

St Mary's looking west, showing a lost ecclesiastical interior. The ribbed plaster ceiling, organ gallery with heraldic decorations, and box pews were all lost in the Victorian restoration. The Champneys monument, on the right, was moved.

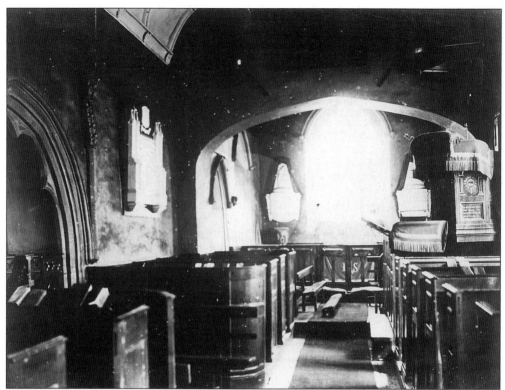

The view inside the church looking east. The pulpit and reading desk are draped with fringed velvet. The text and decorations of the pulpit were cleaned off during the restoration.

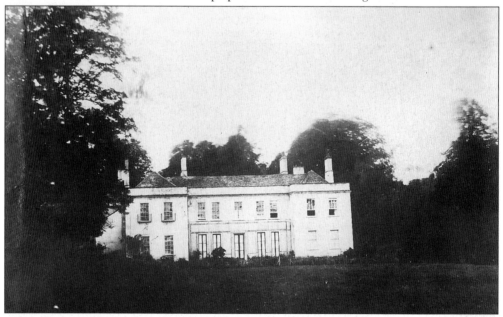

The east front, added in the eighteenth century, of the old manor house at Orchardleigh. It was the home of the Champneys from 1440 to 1839 and demolished in 1860. Low and damp, frogs were said to come out of the lake and serenade the dining room windows.

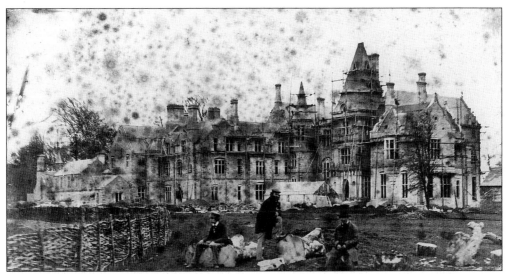

The new mansion at Orchardleigh during the course of construction in 1857. It is still encased in scaffolding and surrounded by piles of stone. The photograph, one of a series was taken by the son of the house, Revd W.A. Duckworth, a talented early photographer.

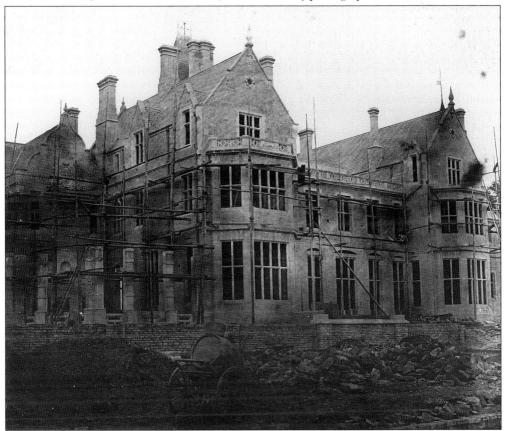

A closer view of the south front in June 1857. The mansion, built of Bradford stone with Bath stone dressings, was designed by Thomas Henry Wyatt. The estimated total cost was £40,000.

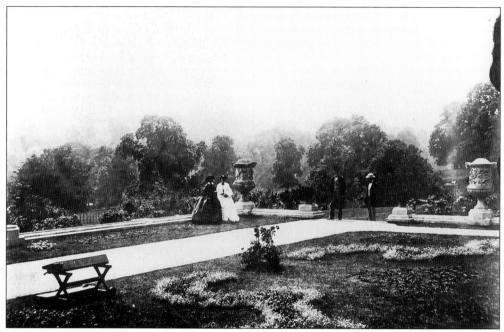

William Bridgewater Page, a nurseryman from Southampton and proprietor of the botanic gardens there, laid out the splendid south terraces at Orchardleigh. Here guests of the family enjoy them in July 1859.

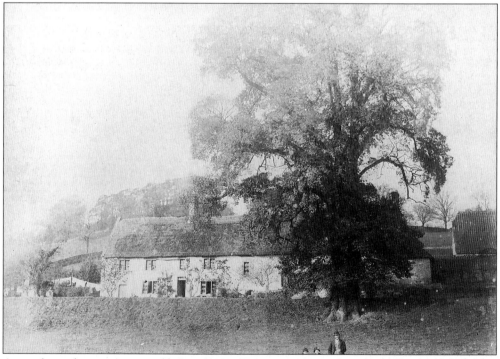

Apart from the mansion itself, Longhouse Farm was the only other substantial house in Orchardleigh parish and a good example of the thatched vernacular style. It was burnt down on 4 July 1893.

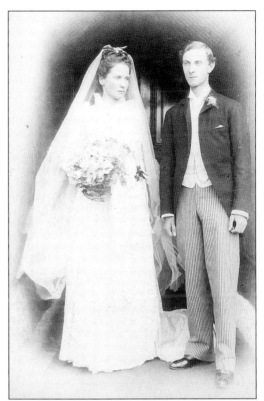

The poet and author, Sir Henry Newbolt, as a young and impecunious lawyer, married Margaret Duckworth, daughter of the great house, at Orchardleigh church in August, 1889. Orchardleigh inspired him to write *The Old Country* and *Fidele's Grassy Tomb*.

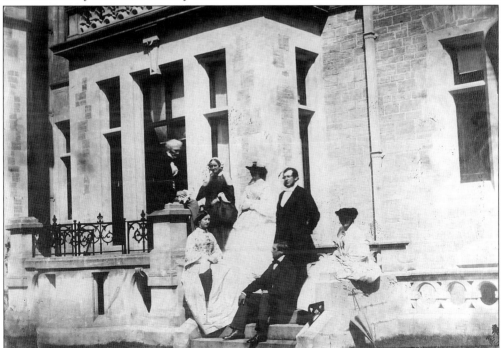

Formal family group at Orchardleigh House in July 1859. On the left is William Duckworth, builder of the mansion, with his wife.

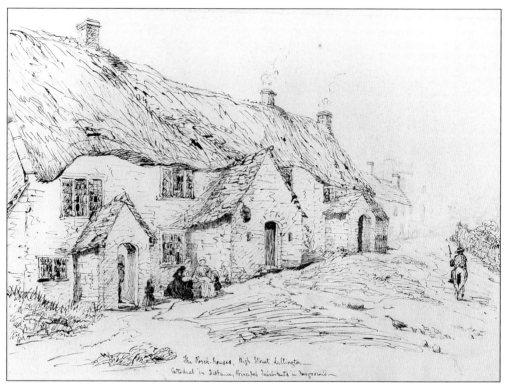

When the Duckworths bought Lullington in 1855 it was said to be 'not worth having'. They turned it into a model village. This drawing is dated 12 August 1858, and inscribed: 'The porch houses, High Street, Lullington – cathedral in distance. Principal inhabitants in foreground'.

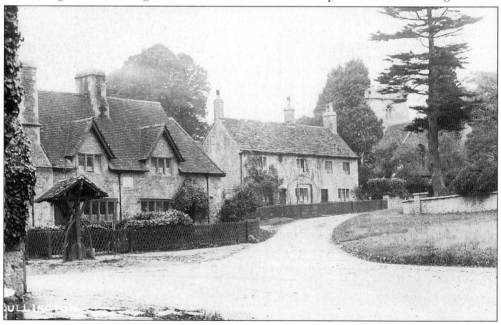

Lullington showing 'The Porch Houses' on the left, *c.* 1920. These were rebuilt for William Duckworth to the designs of George Devey in 1871.

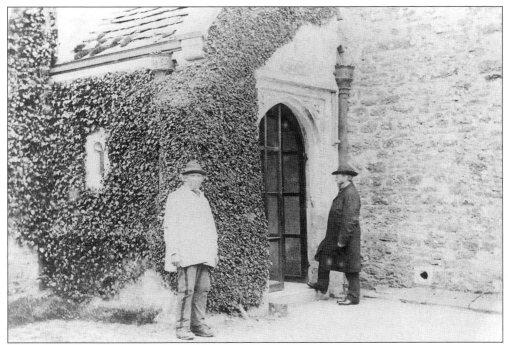

Revd John Medley (right) was incumbent of Lullington and Orchardleigh from 1875 to 1890. He is seen here about to enter All Saints church. The sexton, James Osment, is in attendance. Reproduced by kind permission of Somerset Record Office.

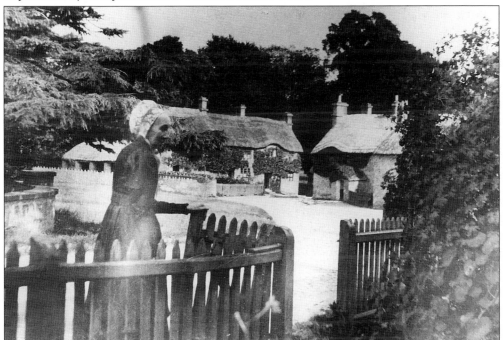

A photograph of Sophie Senn, the Swiss governess to the daughters of the Duckworth family, as they are about to leave her cottage in Lullington. The Duckworths were devoted to her. She died in 1910 and is buried at Orchardleigh.

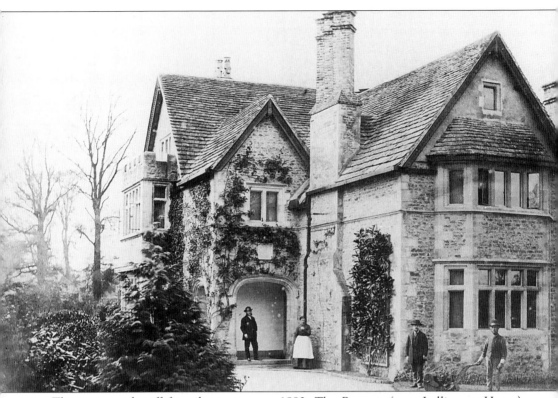

The rector and staff face the camera, c. 1880. The Rectory (now Lullington House) was especially commissioned by William Duckworth and completed in 1866. The architect was George Devey.

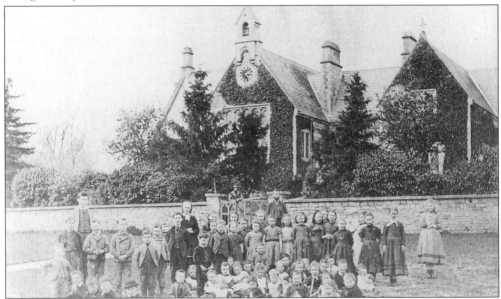

Lullington School, 1890. This enormous school at Lullington could take more than one hundred people. It was given by Mrs William Duckworth, designed by Thomas Henry Wyatt, and completed in 1858. It is now a private house.

Eight
Marston Bigot and Witham Friary

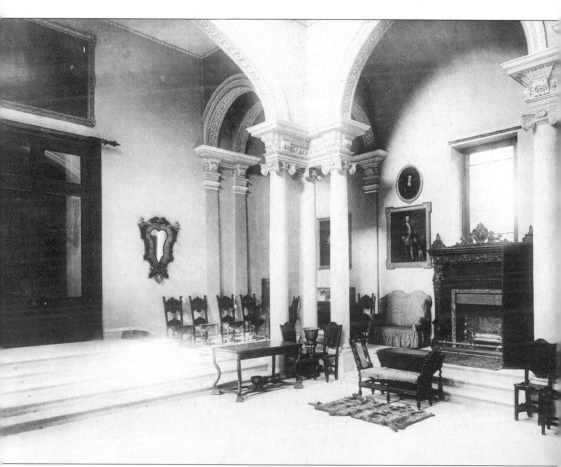

Marston House was the seat of the Earls of Cork and Orrery from 1641 until 1905. Photographs of the interior are rare and this one of the great entrance hall is from the 1905 sale catalogue. The Great Hall, based on a drawing in Swan's *Collection of Designs,* was the work of Major Charles Davis, the Bath City Architect, when the house was turned back to front in 1856/58. Derelict in 1984, the hall has been splendidly restored by its present owners, Foster Yeoman Ltd.

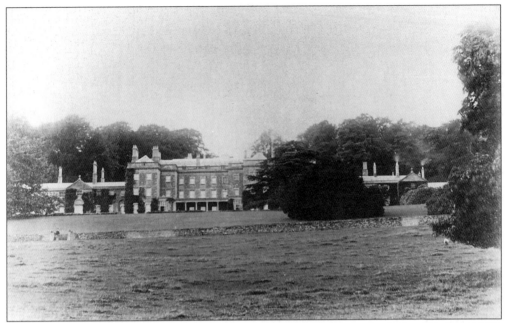

Tall chimneys at Marston House towards the end of its ownership by the Earls of Cork, *c.* 1890. The main house was built in 1600, the wings were designed by Samuel Wyatt and added in 1776. This photograph was taken by F. Hoare, of Cirencester, and is in a private album at Longleat. Reproduced by kind permission of the Marquess of Bath.

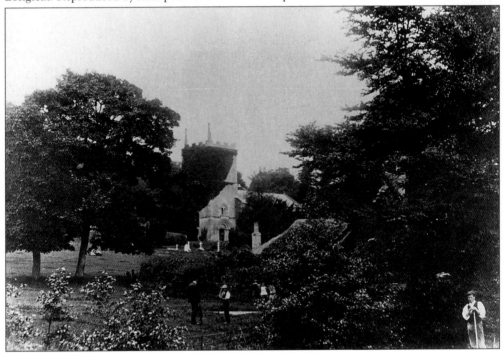

St Leonard's at Marston Bigot, a haunt of rural peace, with the thatched roof of the Church Lodge just visible amid the foliage, 1890. Photograph by Hoare reproduced by kind permission of Lord Bath.

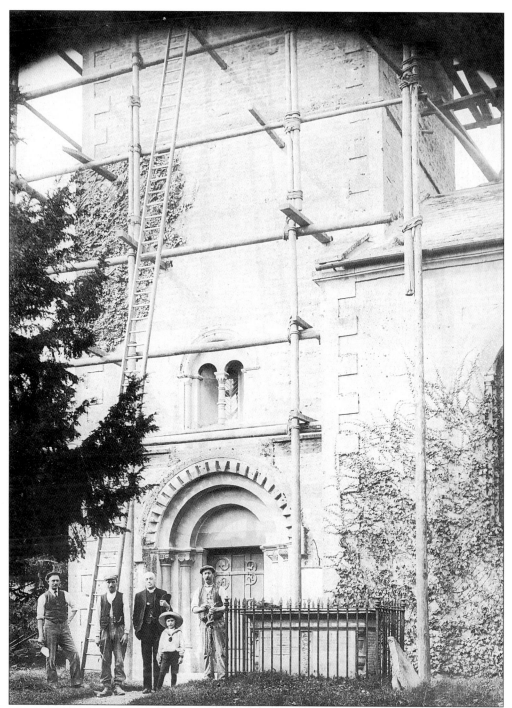

The bells of Marston church were rehung in 1913. Wooden scaffolding surrounds the tower. The Rector, Revd and Hon. Noel Waldegrave, stands with the workmen and with his young son. Both succeeded in turn to the Waldegrave earldom. The bells are renowned for their sweet tone and peals are regularly rung from the tower.

An atmospheric scene near Church Lodge, emphasising the slow pace of country life, captured by Hoare in 1890. The road over Cheese Hill, properly Chizzle, is now tarmacked and enclosed. Reproduced by permission of Lord Bath.

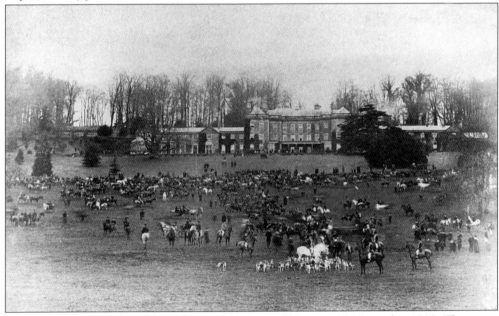

The meet of the Royal Buckhounds outside Marston House on 23 November 1882. This was a red letter day in local history. The ninth Earl of Cork was master of the Queen's hounds and brought them to Somerset to celebrate the twenty-first birthday of his son and heir, Lord Dungarvan. He brought a stag hunt called Hurley-Burley which, after the hunt, returned to Windsor unharmed.

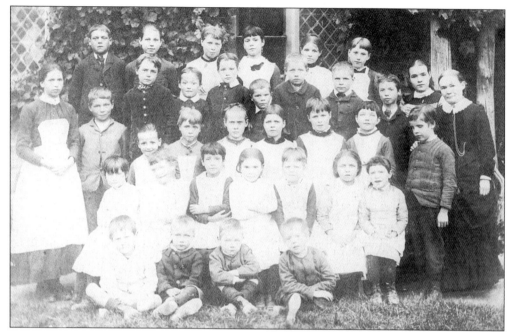

Marston children with their teacher and her assistant pose outside the school, *c*. 1890. The school now restored as a private house, was given to the parish by the Revd and Hon. R.C. Boyle in 1857.

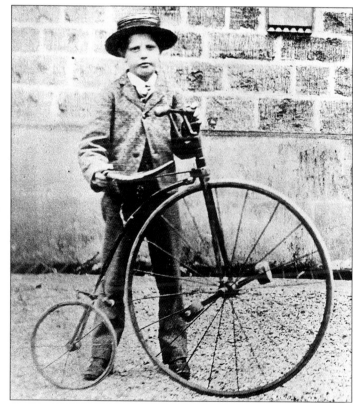

A boy with a penny farthing, the Hon. Robert Boyle who later became the eleventh Earl of Cork and Orrery, outside Marston House about 1870.

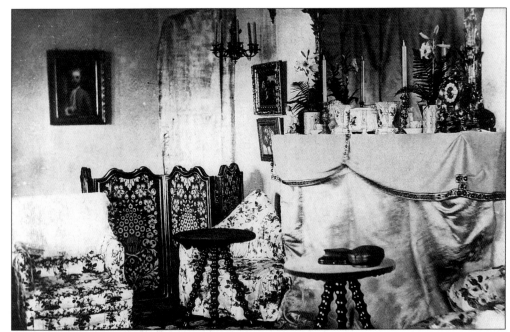

A Victorian interior at Marston Rectory, with typically fussy furnishings of the day, 1870. Marston Rectory was built by the eighth Earl of Cork for his son, Revd and Hon. R.C. Boyle, rector of the parish in 1836.

During the Revd R.C. Boyle's long incumbency, between 1836 to 1875, he became particularly concerned with Gare Hill, a poor part of the Cork estate. He was instrumental in building a church there and decent housing. These were long known as Richard's Cottages, named after his Christian name.

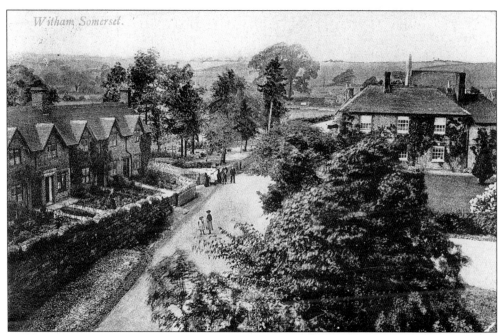

Witham Friary, with the Seymour Arms on the right and the parish church behind it, 1914.
Witham Friary was a remote village known to some as the site of the first Carthusian priory in
England and to others as a railway junction.

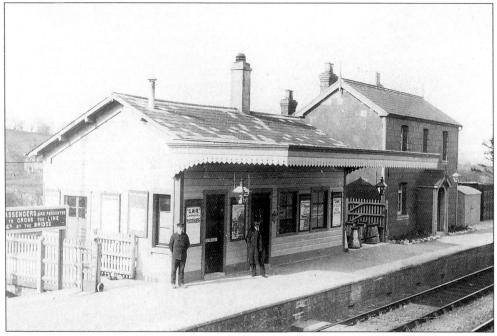

The Wilts, Somerset and Weymouth Railway came to Witham in 1857 and a branch line was
opened to Shepton Mallet and eventually to Wells in 1858. The junction put Witham on the
map. The station was Brunelian in spirit and had the stationmaster's house right on the
platform. It closed in 1965 and the buildings were demolished.

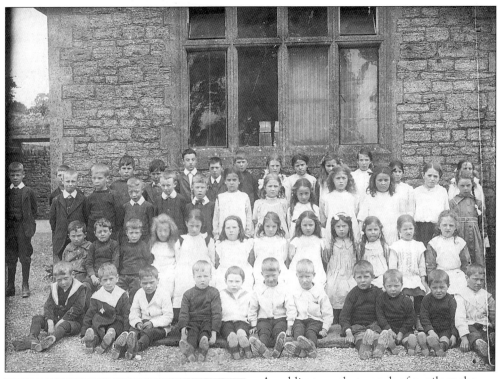

An obligatory photograph of pupils at the Witham School, c. 1910. The school, now the village hall, was built by the Duke of Somerset in 1838 and continued in use until a new one was erected with a large catchment area at Upton Noble in 1965.

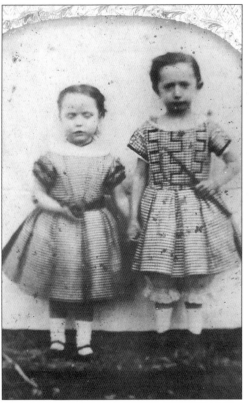

Two Witham youngsters, c. 1865. They were the children of Richard White, a yeoman farmer of Bellerica. Kate married Edward Croom, a neighbour at Great Westbarn Farm. Arthur farmed at Lower Westbarn from 1887 until the First World War.

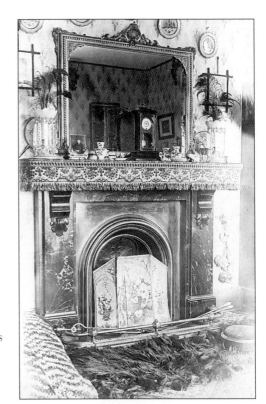

The parlour, at Quarr Hill Farm, *c.* 1910. This was the best room and used only on special occasions. Quarr Hill was farmed by the Crooms, a leading local family, for two hundred years.

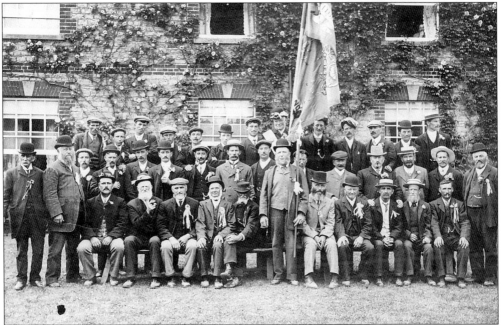

Members of the Witham Friendly Society gather at the Seymour Arms before a procession, sermon and feast, *c.* 1910. Every village once had its 'club' or Friendly Society to help in times of ill-health. Most have long since disappeared but that at Witham, founded in 1786, still flourishes.

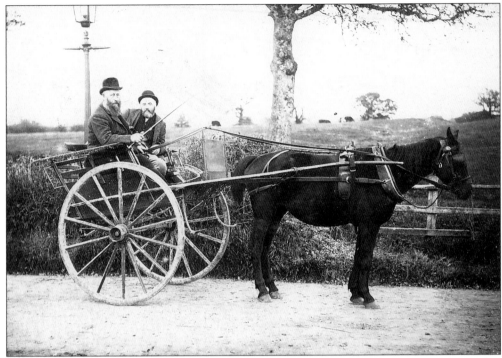

Rezia Hallett, of Sweetnap and George Powell, of Moor Park, on their way to Frome market about 1910. They usually took the train to Frome but on this occasion drove all the way there and back. The standard carried a paraffin lamp extinguished at 11p.m.

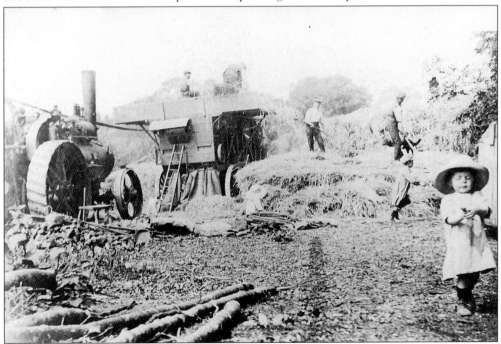

Threshing at Quarr Hill Farm, c. 1915. The little boy on the right is John Croom, now living in Devon.

Robert Croom, of Quarr Hill. A leading member of the local community and respected tenant of the Duke of Somerset, he was representative of the affluent yeoman farmer.

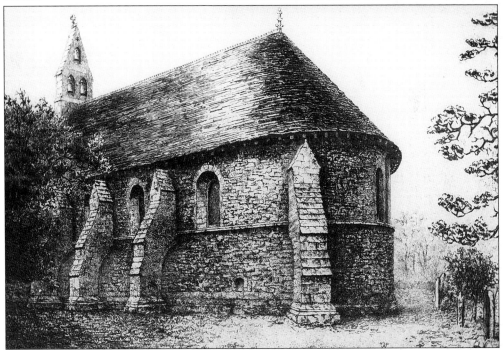

An etching of Witham church by E. Piper in 1900. The church, dedicated to the Virgin Mary, St John the Baptist and All Saints, was the lay brothers' chapel of the monastery founded here by Henry II. The bellcote, high-pitched roof and buttresses, date from its restoration in 1875.

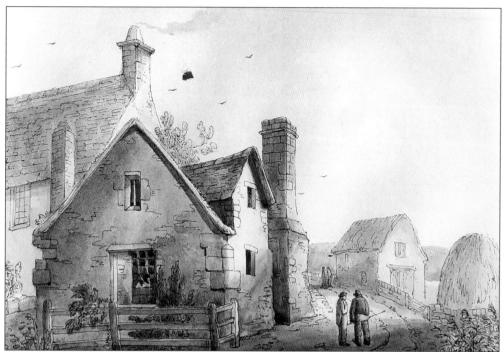

The building in the foreground of this work by W.W. Wheatley, painted in 1845, is thought to be the remains of the Frary Grange, home to the lay brothers who served the Carthusian monks. It was taken down in 1850 when Manor Farm was extended.

The Croom family outside another of their farmhouses, the elegant Great Westbarn, now Westbarn Grange. The old farmhouse is at the back and was given an imposing new front about 1730, by the Thistlethwayte family who owned it for two hundred years.

Nine
Mells and Leigh-on-Mendip

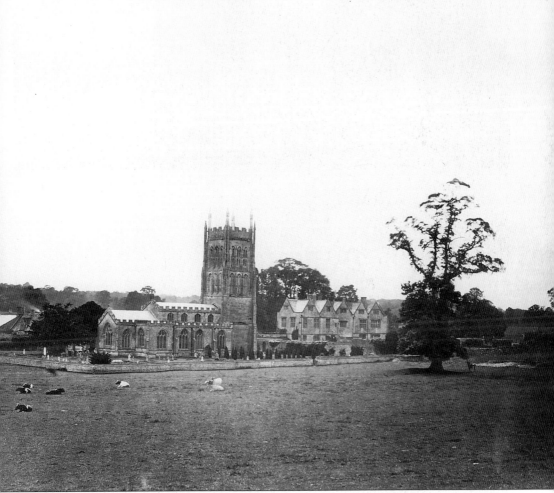

St Andrews church, taken by Munro, the first Frome commercial photographer, c. 1863. The grouping of church and manor house is quintessentially English but few are so happily picturesque as the arrangement at Mells. St Andrew's church is in the Perpendicular style and was described by John Leland, the kings antiquary, as having been built 'yn tyme of mind' when he visited about 1540. It possesses one of the finest towers in Somerset, measuring 104 feet high. Leland also saw 'the manor place' of John Selwood, Abbot of Glastonbury, close to the west end of the church where it remains today.

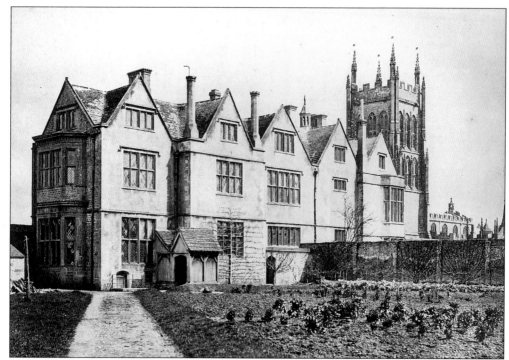

Mells Manor House viewed from the south, *c.* 1860. It is the surviving wing of an H-shaped house built by the Horner family who bought it from the crown in 1543. It is still the home of their descendant, the Earl of Oxford and Asquith.

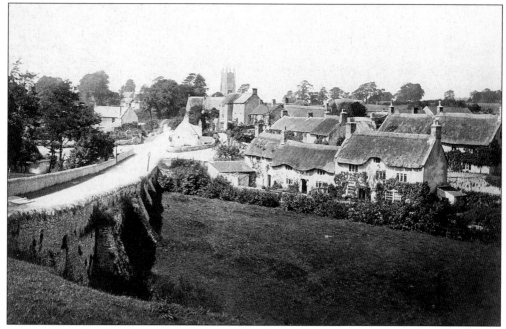

A view of Mells from the slopes of Limekiln Hill, *c.* 1880. The thatch has now been largely replaced by slate and tile. In the centre, the houses can be seen 'somewhat clinging' to its central rocky spine, as described in 1540.

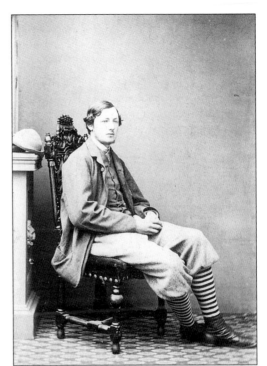

A portrait of Sir John Horner (1842 - 1927) at the age of twenty, by F.C. Bird of Frome, 1862. He was the last of his name to be Squire of Mells. He presided over village affairs for more than fifty years and was also commissioner for woods and forests.

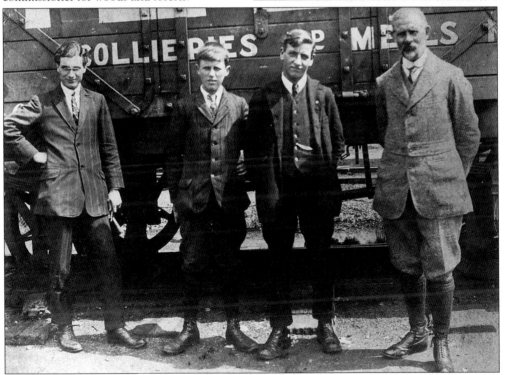

The office staff at Mells Pit, c. 1910. Although apparently rural, Mells has always been associated with industry, especially wool, iron, stone and coal. From left to right: Gilbert West, chief clerk, Chris James, clerk, Herbert Withers, dispatch clerk, and Mr Wyatt, secretary.

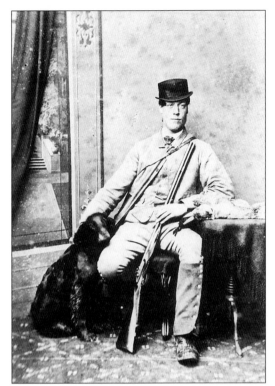

Richard John Hames was gamekeeper to Sir John Horner for sixty years. He was described as honest, intelligent and sober. In one year under his direction 2,477 pheasants were killed on the estate. He died in 1929, aged eighty-five. This powerful portrait was the work of Frederick Bird, of Frome, when Hames was twenty-one years old.

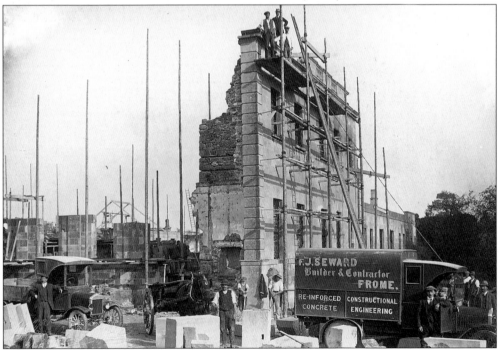

Workmen from F.J. Seward, demolish the ruins of Malls Park House, prior to the building of the new Park House designed by Sir Edwin Lutyens, 1924. An electrical fault caused an appalling fire which destroyed Malls Park House in October 1917.

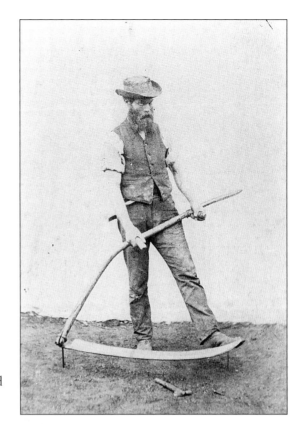

William Wise, an expert in his field and
sexton at Mells in 1883, demonstrates
his skill with the scythe.

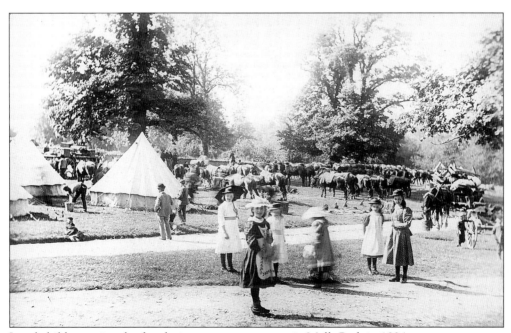

Local children enjoy the fun during a yeomanry camp in Mells Park in 1894.

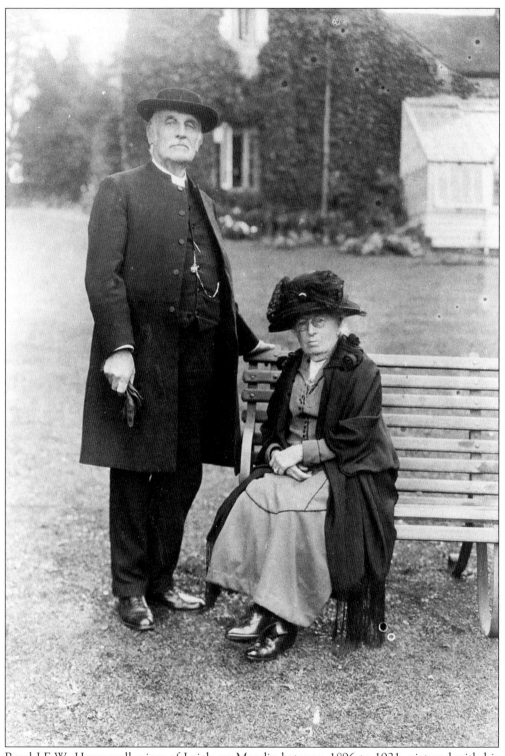

Revd J.E.W. Honnywell, vicar of Leigh-on-Mendip between 1896 to 1921, pictured with his wife at the vicarage. Originally a farmhouse, dated 1598, the vicarage has now been sold off.

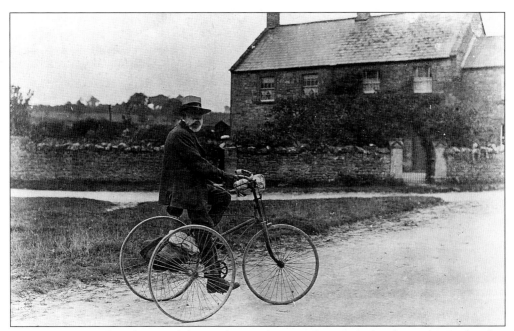

William Moon, village boot and shoe maker, on his tricycle at Townsend, c. 1880. He lived in a small cottage at the end of the Bell Inn.

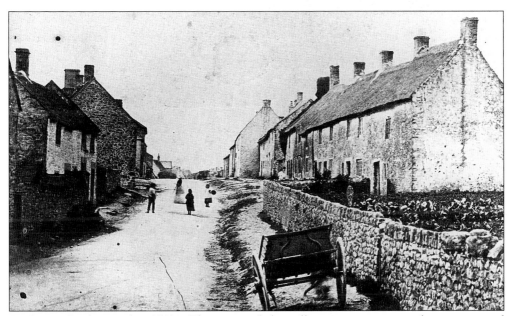

Leigh-on-Mendip in the 1860s. This view of the village street captures the poverty and desolation of so many Somerset villages in the Victorian period.

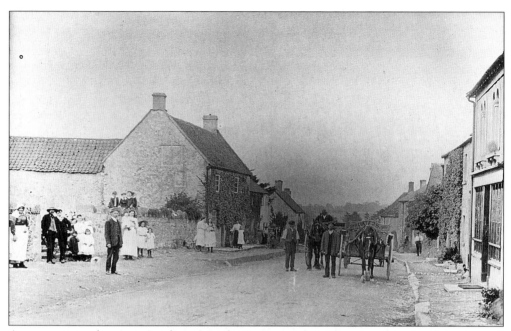

A more animated scene in Leigh-on-Mendip Street, *c.* 1910. There is an air of anticipation and it may be the day of the flower show or school treat.

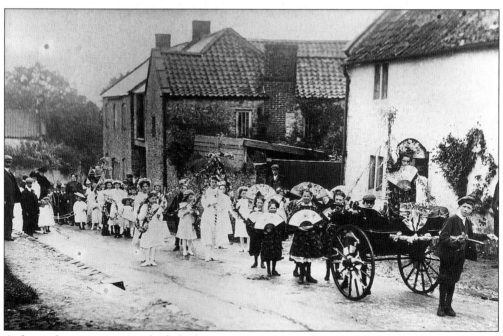

A fancy dress procession which had an exotic Japanese flavour, 1906. The school fete was always marked by a procession through the village.

Three generations of the Padfield family at Leigh, *c.* 1910. Edward (or Edwin) with his wife Louisa (from Coleford), son Frank, and grandson, Bernard, in the yard of their cottage. Frank is believed to have been a soldier or policeman who died fairly young.

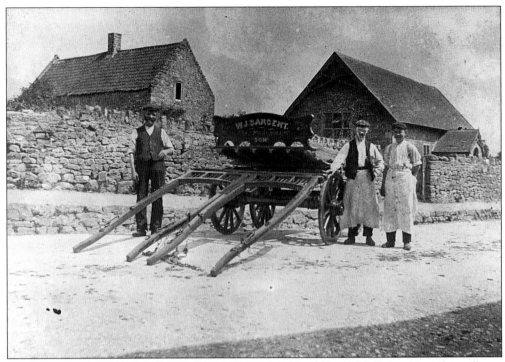

Leigh-on-Mendip School with W.J. Sargent's waggon outside, c. 1906. Sargent was the miller at Coleford, the neighbouring village.

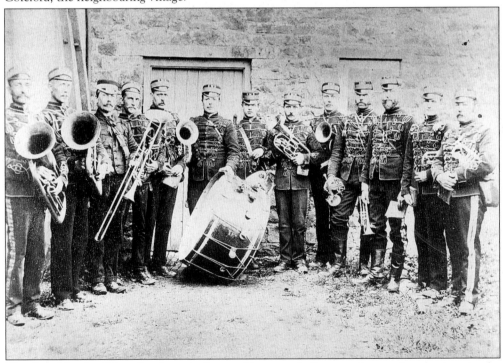

The East Mendip Silver Band, an indispensable part of all processions and gatherings in the Leigh area, c. 1900. Members were mainly Coleford men but a few from Leigh were included.

Ten

Nunney, Great Elm and Whatley

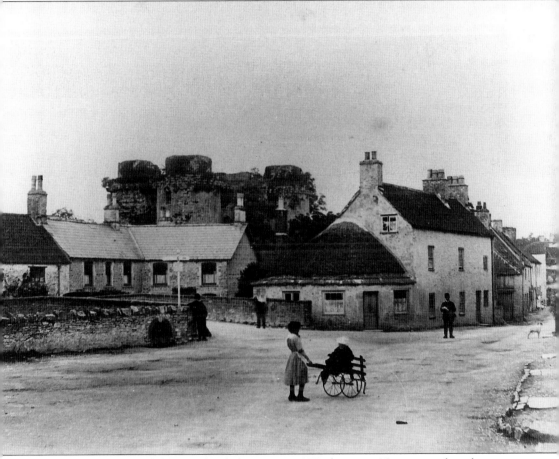

The ruins of the castle, built by Sir John de la Mere in 1373, dominate Nunney market place in this photograph taken by F. Hoare, of Cirencester, c. 1880. It evokes the traditional sleepy image of village life. The thatched cottage was the Turnpike toll house. No doubt much of the immobility was for the sake of the picture. Reproduced by courtesy of Lord Bath.

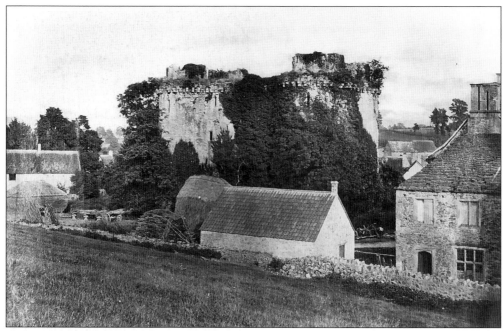

Nunney Castle, showing the North Wall in 1900. The wall collapsed in 1910, having been weakened by bombardment during the Great Civil War. Ivy and traditional haystacks add to the charm. On the right is the back of the manor house.

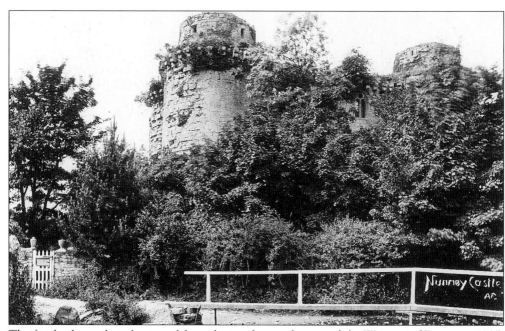

The footbridge and castle viewed from the south in a photograph by Watson, of Frome, c. 1905. The rampant vegetation disappeared when the ruins were consolidated in 1926 by the then Ministry of Works.

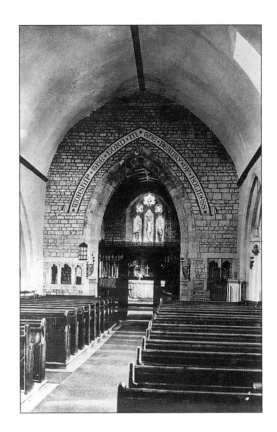

All Saints at Nunney, one of a series of photographs by Watson, *c.* 1905. It shows a lost view of the interior, with the original waggon roof now hidden by a false ceiling. At the top right a vanished clerestory window is indicated.

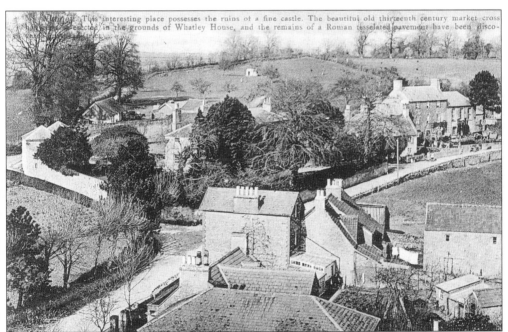

An unusual view, taken from a postcard by Wilkinson of Trowbridge, of Nunney from the tower of All Saints church, *c.* 1914. The view is towards Fulwell House and The Delamare.

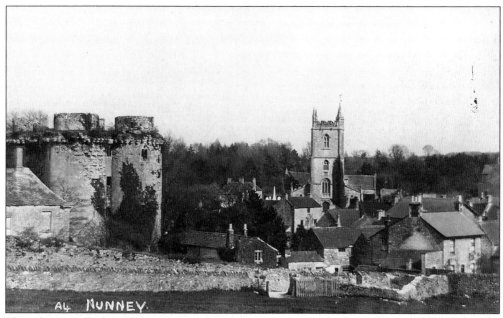

This photograph, by Watson, succeeds in capturing not only the village itself but also the manor house (on the extreme left), castle, and All Saints church.

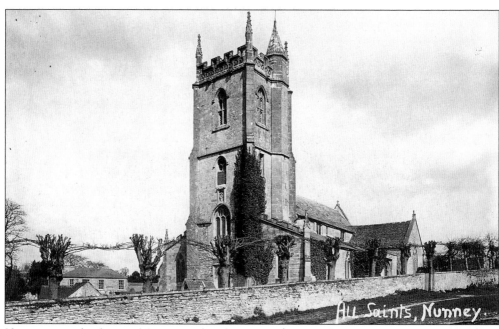

If not among the finest of Somerset church towers, that at All Saints is handsome enough. It has three stages and dates from about 1500. The crown with its quatrefoils and arches is particularly fine. On the right is the clerestory which was removed after the Second World War.

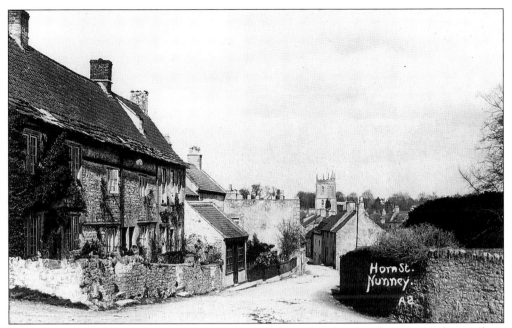

Horn Street probably gets its name from its curved shape. It is lined with attractive houses from various periods in the seventeenth and eighteenth centuries. Here also was the mill and Blindhouse.

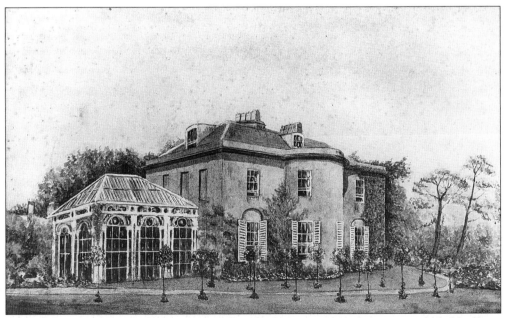

Rockfield, painted by Miss Peacock one of its residents, c. 1890. Nunney is remarkable for its substantial gentry houses. Rockfield, a corruption of 'rackfield', where cloth was dried, may have been designed by John Pinch, the Bath architect. Thomas Dallimore commissioned it in 1806. The conservatory has been rebuilt and a wing added on the left.

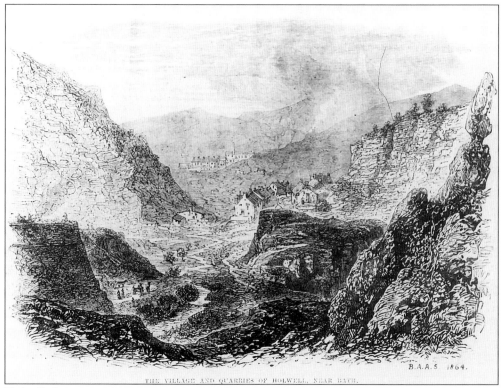

Holwell Quarry, 1864. Quarries were rarely picturesque enough to attract the artist's pencil. This atmospheric drawing was reproduced in *The Illustrated London News*. Holwell was known for its limekilns as early as the eighteenth century.

Glebe Farm at Great Elm, typical of the many farmhouses of the Frome area, on a winter's day in the 1880s. On the left is the parish church.

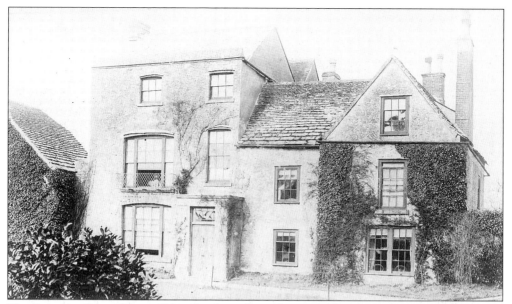

The Rectory, Great Elm, *c*. 1880. On the right is the original eighteenth-century house with stone-tiled roof while on the left is a double pile late Georgian extension.

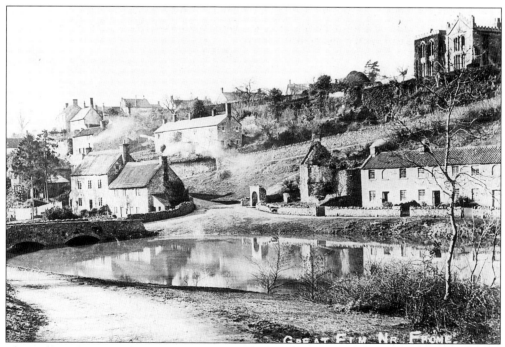

The millpond at Great Elm at the end of the nineteenth century. A handsome thatched farmhouse by the bridge and a row of cottages on the right used by workers at the iron mill can be seen. On top of the hill is Elmhurst, a Gothic revival mansion, which later burnt down.

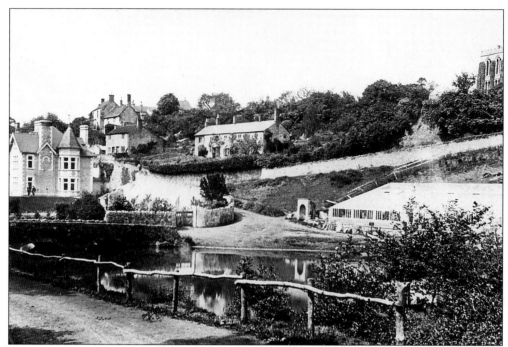

The millpond had been railed off by 1910. The thatched farmhouse has been replaced by 'Glenthorne' (extreme left) and the row of cottages replaced by glass houses.

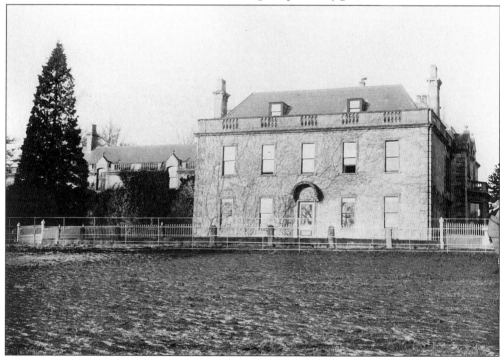

Whatley House shown in good order, c. 1910. The Shore family were connected with Whatley from the late seventeenth century. Whatley House was the family seat until 1959. Partially damaged by fire, it was then sold for £2,000.

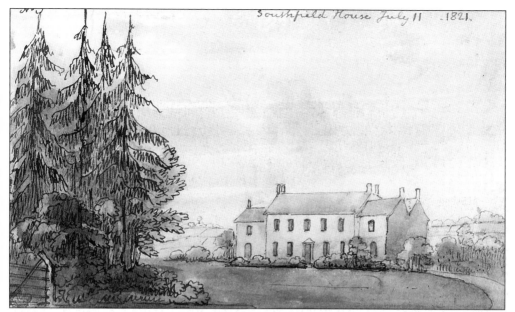

Southfield, drawn by Revd John Skinner, the antiquary, in 1821. Southfield was the second Shore mansion, built about 1809, but for many years was let out. From 1829 until 1923, it belonged to the Horner family, of Mells. The drawing is reproduced by kind permission of the trustees of the British Library.

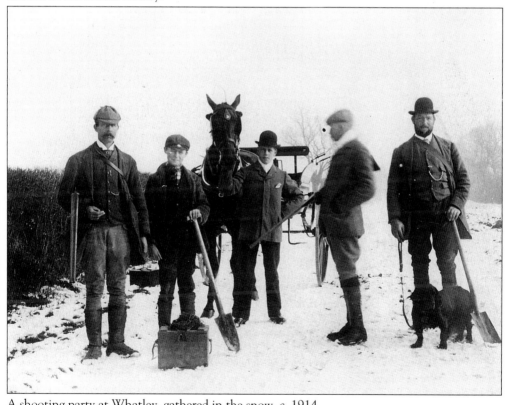

A shooting party at Whatley, gathered in the snow, *c.* 1914.

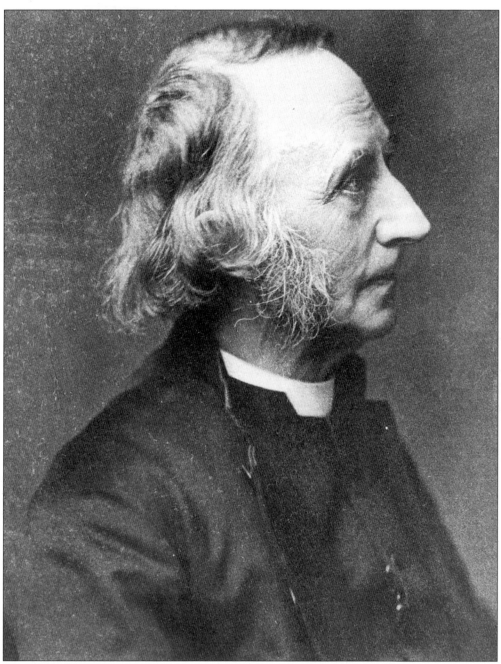

Revd R.W. Church came to Whatley as incumbent in 1852 and became Dean of St Paul's. He restored the church, and his voluminous 'Village Sermons', given here, were later published in three volumes. When appointed Dean of St Paul's in 1871 he left Whatley with regret, always remembering its green fields and flowers, its good sun and air and the kindness of friends. He died in 1890, aged seventy-five, and is buried in the churchyard.